THE BRIDGE OF CRITICISM

Egie Grishi

THE BRIDGE

OF CRITICISM

DIALOGUES AMONG LUCIAN, ERASMUS, AND
VOLTAIRE ON THE ENLIGHTENMENT—ON
HISTORY AND HOPE, IMAGINATION AND
REASON, CONSTRAINT AND FREEDOM—
AND ON ITS MEANING FOR OUR TIME

by Peter Gay

HARPER TORCHBOOKS ❦
Harper & Row, Publishers, Inc.
New York, Evanston, and London

First HARPER TORCHBOOK edition published 1970

To Bertha Tumarin

> . . . to impose is not
> To discover. To discover an order as of
> A season, to discover summer and know it,
>
> To discover winter and know it well, to find,
> Not to impose, not to have reasoned at all,
> Out of nothing to have come on major weather,
>
> It is possible, possible, possible. It must
> Be possible.
> —WALLACE STEVENS

CONTENTS

"I have sometimes thought of writing a dialogue of the dead in which Lucian, Erasmus, and Voltaire should mutually acknowledge the danger of exposing an old superstition to the contempt of the blind and fanatic multitude."

—EDWARD GIBBON

I ON MODERNITY

1. ON MODERNITY

LUCIAN

It was good of Gibbon to bring us together by thinking of us in the same sentence.

ERASMUS

So it was: for civilized spirits, conversation gives contours to eternity.

VOLTAIRE

Our opportunity, gentlemen, is welcome indeed, but our assignment is absurd.

LUCIAN

It is nothing less. Gibbon, I see, wants us to acknowledge the danger of exposing an old superstition to the contempt of the blind and fanatic multitude. Well: I never addressed, and certainly never reached, the multitude.

ERASMUS

Neither did I. I educated only the educated.

VOLTAIRE

You may rest easy: I am his real target. I remember the fellow well: he used to come to my house, a lively, nasty, feline little man, all wit and no charity. And in his own writings he did his bit to pour contempt on the old superstition that we both detested. But then came the French Revolution, and all his old daring gave way to undignified panic. He was too much the scholar, I fear, to take responsibility for his own radical opinions. But we must not let him determine our view of the Enlightenment. There was a great deal more to the Enlightenment than the rousing of the mob and the making of atheists.

LUCIAN

Frankly, I would much rather debate your version of the Enlightenment than Gibbon's.

ERASMUS

And what is to prevent us? We may be spirits, but we are now what we were in our lifetime: free spirits.

LUCIAN

Well, before we leave Gibbon, one question: Voltaire, when Gibbon wrote, he only had the French Revolution to blame you for. I wonder what he would make you responsible for now, two centuries later?

VOLTAIRE

Everything, I suppose, that is wrong with the twen-
tieth century, and nothing that is right. To be
abused as a scoundrel, scorned as a madman, or
burned as a heretic is the lot of the philosopher
who tells the world the truth.

ERASMUS

But, my dear Voltaire, you didn't tell the world the
truth; you lied, persistently and systematically.

VOLTAIRE

I was prudent, my dear philosopher. I lied that I
might live to tell the truth another day—as you did
in your time.

ERASMUS

I did not lie; I merely held back the whole truth,
which is something else again. You compromised
your program with your performance: bad means
corrupt good ends. A reformer who spends his life
lying ends up, not a wily reformer, but an old liar.

VOLTAIRE

You may not believe me—since I am the old liar you
are speaking of—but by and large I agree with you.
Contrary to our reputation, we philosophes did
not really enjoy publishing our books under as-
sumed names, professing to believe what we really
despised, or concealing our convictions behind
subtleties and fictions. Our enemies gave us no
choice; had they given us freedom to criticize freely,

we would have criticized freely, and we would have had less to criticize. As it was, we had to protect ourselves from our Christian neighbors.

LUCIAN

You men of the Enlightenment, it seems to me, need as much protection from posterity as you needed from your contemporaries. Here you are being scolded for having lied too readily when Gibbon scolded you for telling the truth too publicly.

VOLTAIRE

As one of your admirers, Lucian, I am pleased to see you so sympathetic.

LUCIAN

I am sympathetic, for we were allies in the same cause.

ERASMUS

The same cause? You astonish me.

LUCIAN

Some causes are never won—or, rather, must be won over and over again. The god of stupidity is immortal, and nonsense has more lives than the proverbial cat. I witnessed the rise of the most successful mystery cult the world has ever seen— Gibbon's "old superstition" was a young superstition in my day—and the Enlightenment hastened its decline. That is sufficient reason for sympathy. Besides, there were many philosophes—Wieland, and Hume, and, of course, Voltaire here—who did me the honor of imitating me.

ERASMUS

I, too, imitated you!

LUCIAN

Yes, though more in form than in philosophy. The men of the Enlightenment are my true heirs. I feel—forgive me, Erasmus—closer to Voltaire than to you. History has logical quite as much as chronological affinities. I like to remember that even Gibbon praised me, and he praised few men.

VOLTAIRE

Gibbon! He praised only the dead, to conceal how much he owed the living. But we have had to suffer far greater calumnies than his in these two centuries. In our time it was fashionable to denounce us for lacking all principle; more recently, it has become the fashion to denounce us for being too rigid in our principles: from being irresponsible, celebrity-hungry scribblers we have become ruthless, bloodthirsty fanatics.

ERASMUS

You will admit that men of ideas—and especially men of one idea—are often fanatics.

VOLTAIRE

I do. I spent my life among Christians.

ERASMUS

There were fanatics among my fellow believers, I know. But I am referring to a different breed—yours. There were fanatics in the French Revolu-

tion—your child!—more self-righteous than Calvin and more brutal than Luther. And since then the world has been plagued with reformers ready to kill all mankind in their eagerness to improve it.

VOLTAIRE

There are fanatics in all camps, and probably always will be. Why should I deny it? No philosophe ever thought that fanaticism, or stupidity, or superstition would ever wholly die out. But we were not fanatics: we knew that there was much we did not know, and some of our enemies were our friends. If there is anything we were fanatical about, it was fanaticism. And make no mistake about the French Revolution: it was not merely a bloodbath or a playground for Utopian experiments. What our critics really hold against us is not the failures of the French Revolution, and its crimes, but its historic success.

LUCIAN

Are you ready, then, to reverse the verdict you ascribed to Gibbon, and say that the Enlightenment is responsible for everything that is right in the twentieth century?

VOLTAIRE

No. But everything that it *is* responsible for is right.

LUCIAN

And in what is wrong it has no share?

VOLTAIRE

Philosophical modesty compels me to agree with you.

ERASMUS

Modesty! I am not surprised that you worked so hard to free pride from the stigma of sinfulness— you had so much of it. Modesty, I know, was your favorite word for yourself, but conceit was your besetting vice.

VOLTAIRE

Conceit is the display of imagined virtues; pride the consciousness of real ones. We took pride in our modesty because it protected us from wishful thinking. And our self-respect is one of our legacies to twentieth-century man.

ERASMUS

I wonder. Are you the father of *anything* in the twentieth century, either good or bad?

VOLTAIRE

We were the first of the moderns.

LUCIAN

The search for roots is a pointless game. Had you lived in the seventeenth century, you would have called *that* modern. Some historians think modernity began with Erasmus; others date it back to the Italian Renaissance. One might just as well say

that the modern movement began with Adam—no, come to think of it, with Eve.

ERASMUS

Precisely. Besides, what does it mean to call yourself modern, beyond wrapping yourself in the mantle of self-approval?

VOLTAIRE

To be modern is to be cut off from the consolations of religion or metaphysics, to be the child—happy or wretched—of science. There is nothing self-satisfied about our claim to modernity: to be modern is as much a burden as it is an opportunity—in fact, it is the very opportunity that makes it a burden. To be modern is to be compelled to face reality.

ERASMUS

Or to evade it?

VOLTAIRE

Often, I fear. But not on principle. To be modern is to be alone—often afraid, often absurd, often vicious. But we, in the Enlightenment, by developing the ideal of freedom, also demonstrated the possibilities of modernity.

ERASMUS

Which you realized?

VOLTAIRE

In large part, I think, we did—enough for others to build on. We showed what it meant to be free from

the illusions of superstition or of system-building. We showed that anything—a moral philosophy, a political system, a social policy, an artistic style—needs persistent testing and reformulation in experience. We showed the way of ending the scandal of interminable squabbles among philosophers; it lies through critical thinking. It is the only kind of thinking by which man can advance beyond the futility of expansive dreams or verbal solutions. In holding nothing sacred, in refusing to stop short before the practices of government, the dogmas of religion, the taboos of sex, or, for that matter, its own procedures, critical thinking alone prods us to revise, improve, clarify, and purify our ideas and our conduct. Being open, energetic, and self-corrective, it compels man to do without the imaginary certainty offered by priests and closet philosophers, and gives him what is far more precious—the relative but authentic certainty that only reliable knowledge can provide.

ERASMUS

As I said: your modesty is a form of conceit. You talk as though you had no forerunners in critical thinking, which is not true. You talk as though religious men never practiced critical thinking, which is not true. You talk as though you philosophes always practiced critical thinking, which is not true.

VOLTAIRE

I protest I never claimed that we philosophes were self-created, unique, and perfect.

LUCIAN

If you did not claim it, you strongly suggested it. Let me warn you in all kindness—I, after all, shared in the critical spirit which you seem to think you invented: by demanding more credit than you deserve, you will get less.

VOLTAIRE

I shall take the warning in the spirit in which it was given. To separate oneself from one's ancestors is not the same thing as denying one's debts. What one says about those ancestors depends upon one's purposes. If you are writing a history of the human spirit, they will be in the forefront; if you are attempting a definition of a movement, they will recede into the shadows. History seeks connections in time; definition, connections in space. Our relations with our ancestors, even our Christian ancestors, were lively and intimate: surely there was far more critical spirit in Locke than in his contemporaries, those Puritan fanatics. If there was a gulf between us and them—the gulf between those who fully possess the critical spirit and those who only partially possess it—the bonds that connected us were close and many.

LUCIAN

I am glad you are willing to concede at least this much, though it is very little. Even if you sought to embody critical thinking in your philosophy and your program, you had been anticipated in classical antiquity.

We had, and we proudly proclaimed it to the world: our admiration for Cicero and Lucretius—and for you, Lucian—was not a secret but a weapon. Our classicism served the aims not merely of cultivating our minds, but of refining our critical faculties. It is no accident that we philosophes greatly enjoyed writing imitations of the ancients: we found so much worth imitating. But if we were pagans, we were modern pagans, separated from the ancients by centuries of experience, and by a secure grasp on science.

ERASMUS

Yet if you were pagans, as you call yourself, you can hardly deny that many pious Christians practiced critical thinking.

VOLTAIRE

I do not deny it: I would not have a Puritan, or a fanatical monk, in my house, but I should be glad to offer you, Erasmus, dinner. I was your disciple in many things.

ERASMUS

With you as my disciple, I scarcely needed critics. I wrote to purify my faith; you borrowed my words to destroy it.

VOLTAIRE

I felt compelled to complete what you began; the only way to purify your religion was to destroy it.

If you want me to accept your invitation, you should also invite other Christians: Swift, who, long before Diderot, discovered the earthly origins of the most celestial ideas; Mabillon, who taught the world how to distinguish a genuine document from a forgery; and the host of Humanists—Christians, good Christians, nearly all of them—who freed Europe from Gothic darkness. You philosophes had no monopoly on Enlightenment.

VOLTAIRE

Fortunately not; and this only made our task easier. We had many witting and unwitting allies, many who distrusted us and did our work. The whole drift of Western civilization was in our direction; the Enlightenment was larger than the philosophes. We were simply its heart and spirit.

ERASMUS

What, then, is your historical merit? You were in the right place, at the right time, with the right words, just as Luther was: he was not a greater man than Hus; he was simply fortunate in the moment of his birth. So were you. Where is your famous bravery? If you had many allies, witting and unwitting, what risks did you really take with your little blasphemies, your little obscenities, your neat, bold-sounding programs of reform? Were you not just saying what everyone else was saying, only more noisily and more impudently? You walked through an open door and then, wiping your brow, took credit for forcing it.

VOLTAIRE

Do you wonder why we philosophes sometimes gave way to self-pity? Here I have helped you to see that we philosophes were part of our century, and often at peace with it, and you choose to take this as proof of our insignificance. Suppose I had told you the opposite—which would have been equally true— that we were often at war with our time. Doubtless you would have chosen to take that as proof of our Utopianism. That is the kind of infallible criticism —condemned if you do, condemned if you don't— that I complained about a minute ago. It is maddening.

LUCIAN

You must accept some responsibility for your maddening situation, I fear; for you have been less than unequivocal about your place in your time. At first you talked as though philosophes and Enlightenment were identical—*le siècle des lumières, c'est nous!*—now you tell us that you were only part of the Enlightenment. Was there one Enlightenment, or were there two?

VOLTAIRE

Both.

ERASMUS

Both? If you believe that, you are ready to believe the mystery of the Trinity.

God preserve me! That one-in-three and three-in-one is a miracle in physics, and I allow no miracle in physics. I was merely trying to summarize a complicated situation. When I say the Enlightenment is one, I am speaking of us, the philosophes, an informal, unorganized, loose association of journalists, private scholars, playwrights, professors, and even a handful of far-seeing statesmen, a family—

LUCIAN

Let me stop you here. The three of us have spoken of "the philosophes" rather freely. And all of us have used those comfortable collective pronouns, "we," and "you," and "they." But can we really do this without doing serious injustice to the differences that divided you? *You*—there! I said it again. To begin with, the very word "philosophe" is French.

VOLTAIRE

It is a French word for an international type, a tribute to our leadership. But we were only first among equals.

LUCIAN

A single type? Really? I can imagine you all in the same room, quarreling: Holbach with Lessing about religion, Hume with Diderot about skepticism, Montesquieu with you about French politics, and Rousseau with all of you about everything!

That is why I used the word "family." We philo-
sophes were not a sect, not a school, not a religious
order. We were a family: the term suits us splen-
didly. We differed, we disagreed, we disputed, and
there were times when we faced one another with
total incomprehension or intense dislike. But we
belonged together, as families do: we attacked sim-
ilar problems in similar ways, and if our answers
did not always coincide, we agreed on what ques-
tions were important. We were, many of us, close
friends or active correspondents. Have you looked
at our letters? They are family letters. Hume felt
at home at Holbach's dinner table, as Franklin
would have felt at home at mine. Even our life his-
tories have certain rough parallels: we all fought
our way free of our inherited religion with the aid
of our beloved Greek and Roman classics—we were
all Ciceronians, all Lucretians—and we all moved
beyond classicism to modernity, to confidence in
the sciences of nature and of man—even Rous-
seau!—and to a commitment to criticism. If you
seek, beneath the traits that are unique to each
of us, an essential quality that unites us as a
family, it is the intellectual style summarized so
beautifully by that word "criticism." It is the
critical mentality that unites Hume and Jefferson,
d'Alembert and Kant, Montesquieu and Beccaria,
Lessing and Helvétius and—yes!—Rousseau. When
I speak of the Enlightenment of the philosophes,
the Enlightenment in its narrow sense, this is what
I have in mind.

LUCIAN

The second Enlightenment is a larger affair, then?

VOLTAIRE

Allow me to draw you a model. Imagine a club in a
city, a city with its professional men and its shop-
keepers, its lawyers and theologians, poets and pro-
fessors, idlers and workmen, servant girls and
prostitutes. And this city (imagine further) lies at
the heart of a small country dotted with lavish
estates, villages, farms, busy factories, with hermits
vegetating in its forests, bargemen poling on its
canals, peasants carousing in its taverns, priests
corrupting novices in its monasteries. The club is
not snobbish or exclusive; it requires no particular
wealth, no ancient lineage, not even exceptional
intelligence—all it asks as a precondition for mem-
bership is a certain agreement on the great public
questions of the day. Now the club, drawing its
members from the city, is intensely interested in
urban affairs, and hospitable to its leading citizens:
even bishops deign to look in once in a while, even
though the most marked intellectual quality of the
club is its outspoken contempt for the city's
dominant superstition. But while the club is in
constant commerce with its immediate environment,
it has little to do with the countryside. But then the
city as a whole decisively and proudly marks itself
off from its rural neighborhood. How then can you
fairly describe the relation of the club to its city?
It draws strength from the city and in turn lends
strength to it; friendships between members and
nonmembers are not merely possible, they are en-

couraged and often intimate: member and non-member friends in particular lend each other books. Can we deny that the club in many ways is the city at its best—its spokesman while, and precisely because, it is its critic? Club members may criticize the city, and even fight it, but they will do so for its good, and in its name. For all but one of its principles—the contempt for the dominant superstition that I mentioned—and even sometimes for that, club members find sympathetic listeners and often active allies in the city: for its schemes to make the law more humane, to improve the treatment of women and children, to lift the shackles of censorship from honest writers, for a dozen other proposals. There are some in the city, notably its bishops, who disapprove of the club, and call its members wreckers and destroyers, but the charge is unfounded or, rather, badly put: the club wants to destroy only in order to build, and build a city in which all can take pleasure. Now the Enlightenment in its wider sense is the club and its city, at harmony and in tension with one another.

ERASMUS

Pretty, but also self-serving. You are asking us to take your private judgment as the judgment of history. You are saying that the members of the club are somehow better than the finest nonmembers— d'Alembert better than Pope, Diderot better than Fielding, you better than Samuel Johnson.

VOLTAIRE

Not at all: the club has its share of leaders, mediocrities, hangers-on, and bores, as all clubs do. And

the nonmembers may include some of the finest poets and purest moralists in the country.

ERASMUS

Your modesty about the defects of your fellows is welcome; so is your generosity about the virtues of your opponents. But your implication remains unimpaired: however much you may try to conceal it, you have an ultimate preference for your side over the other.

VOLTAIRE

Why shall I deny the obvious? I prefer my side to the other side—that is why it was my side. I do believe that we did the work of history; we had help, but our aides would have stopped short at the decisive moment. We for our part decisively advanced the cause of criticism.

LUCIAN

Well, even if we grant that you were more critical in your thinking than your opponents, you were less critical than your ideal prescribed. You made assumptions that no amount of research could have verified, and assertions that no kind of evidence could have falsified—both, as you must know, symptoms of mythical or metaphysical thinking.

VOLTAIRE

Looking at my movement from my new vantage point, I am inclined to admit that we were sometimes rationalists against our will. There were

I : ON MODERNITY

occasions when we substituted rhetoric for research, drew conclusions not because we had proved but because we desired them. We were sometimes as credulous as Christians. We were human, which is to say, insufficiently self-critical. Yet my claim remains intact. With us philosophes, unscientific thinking was a blemish, an inadequate perception, while in the systems we were combating—in rationalist metaphysics, Scholastic philosophy, or open superstition—unscientific thinking was an essential ingredient. What was accidental and undesirable with us was deliberate and desirable with them. Like all men, we fell short of our ideal—unintentionally, for had we detected our shortcoming, we should have tried to repair it. But our ideal remained perfect critical freedom.

ERASMUS

I can see that you in the Enlightenment were no longer medieval men; your style of thinking even differs from that of our Renaissance. Nevertheless, you confronted issues and offered solutions which have little if any relevance to the twentieth century.

VOLTAIRE

If they have become irrelevant, they have become so because we were so right, not because we were so wrong.

ERASMUS

Whatever the reason, your answers sound as remote as your questions.

That is untrue. We anticipated the twentieth cen-
tury in many things. But I would not rest my
argument on anticipations: hunting for ancestors is
the antiquarian's favorite sport, childish like all
his sport; you can always find someone respectable
whose legacy you can plausibly claim. You put it
well, Lucian: The search for roots is a pointless
game—it is of interest only to the rootless. I speak
quite generally, and I repeat: our style of thinking
was modern. If we have been outdistanced here and
there, the measure to which our specific ideas have
become obsolete is a tribute to our philosophy.

ERASMUS

Your logic is charming in its disingenuousness. At
first you insisted that you philosophes had always
been right, now you take pride in how often you
have been proved wrong.

LUCIAN

That, I must say, is a little harsh: it is one thing
to want to have been right about everything, an-
other to hope for historical justice. Still, does being
superseded not make you a little sad, Voltaire?

VOLTAIRE

Why should it? The ideas of theologians are refuted
by their adversaries, the ideas of scientists are
refuted by their followers. For the theologian, ad-
vances are a defeat; we rejoiced in them. If, two
centuries after us, with the methods we handed

down, men still wrote the same kind of history, or knew only as much as we did about astronomy or political economy, there would have to be something radically wrong with these methods. But there is in fact nothing wrong with them at all. Progress, to the extent that there has been progress, has been on the lines we laid down, with procedures we invented or perfected. To the extent these lines or procedures have been discarded, there has been disaster.

LUCIAN

Let us suppose for a moment that your historical claims are just—though I still have my doubts. Yet, when I look at you and your writings, you—and they—strike me as charming period pieces, elegant, adroit, yet too bland, too toothless for the modern taste. I see you—all but Rousseau, perhaps—in powdered wig, lace ruffles, with silver buckles on your shoes. You were—at least to a century of leather jackets and concentration camps, you must appear to be—how shall I say it?—rococo reformers. Can you expect to speak to the twentieth century, an age brought up on philosophies of the absurd, drenched in nihilism, hardened by organized murder, deafened by the noise and blinded by the glitter of mass civilization? To administer your writings to modern man is like holding out a twig to a drowning swimmer: he may freely appreciate your attentions, but you will not save him. I grew up in the classical tradition which taught that works of art and literature must improve the reader as well as entertain him. Will your ideas improve the

reader of the twentieth century, or will they merely entertain him? Some eighteenth-century books no doubt retain their charm—your *Candide,* my dear Voltaire, which, I believe, owes much to one of Erasmus' productions, still amuses people. But will they change men's lives? I doubt it.

VOLTAIRE

What you say has long worried me deeply. It is curious: the ruthless radical of one generation may strike the next as a perfumed dandy. I am not certain that the world will listen to our message. I said in my own time that the world is a shipwreck, and there is no evidence that it is any less of a shipwreck now. My only hope is that there may come a time when people tire of shouting, when men of letters will grow bored with their game of outbidding their rivals with their absurdities. My hope, in a word, is that people will finally listen to us because they should.

ERASMUS

I do not believe, of course, that they should, but I rest easy: I have no fear that they will—though they will doubtless reject you for the wrong reasons. What Lucian said is true enough; not even reasonable men in the twentieth century will be induced to listen to you . . . rococo reformers. A felicitous phrase!

VOLTAIRE

Why are you so certain?

ERASMUS

Because the modern temperament is dominated by characteristics that you lacked.

VOLTAIRE

And these are?

ERASMUS

Lucian has already suggested what they are. What governs twentieth-century thinking, and was absent from yours, is historicism, secular pessimism, the creative imagination, and existentialism.

VOLTAIRE

Is that a criticism or a compliment?

LUCIAN

You are, my dear Voltaire, in a mood for paradoxes. Let me supply your answer for you: it was meant as a criticism, but you take it as a compliment.

VOLTAIRE

You are cleverer than I am—too clever this time. I do not imagine that Erasmus is inclined to be critical of the Enlightenment for lacking qualities that he himself lacked.

ERASMUS

True. It is a complicated matter. At the moment I am concerned to show not that you were wrong— though you *were* wrong—but that you are irrelevant.

Well, Erasmus, you are right in this: it is a complicated matter. In fact, the Enlightenment had mastered all the modes of thought you mentioned, though in their beneficent qualities alone. For they were all mixed blessings, all dangerous gifts. The historian's attempts to penetrate the past fully and fairly has degenerated into abject apologies for revolting power politics. Pessimism has seduced men into fashionable superstitions that have sapped their will without clarifying their thought. The modern view of the imagination has become an excuse for art by children and madmen. And existentialism, the child of confusion and despair, has only perpetuated both. Far from flinching before the charge, I take pride in the knowledge that the philosophes were not twentieth-century historicists, pessimists, merchants of fancy, or existentialists. I shall go further: precisely the things that distinguish us from the twentieth century are our message to that century and may bring it back to sanity. Precisely the qualities that make it hard for us to get a hearing make our message valuable.

ERASMUS

I repeat: they will not listen to you. And if they did, this would not bring them back to sanity.

VOLTAIRE

I am sorry to see that you are still praising folly, Erasmus, not in irony this time, but in deep earnest.

LUCIAN

Gentlemen! A wrangle is not a debate.

VOLTAIRE

There is, I fear, very little to debate.

LUCIAN

You are mistaken: we have everything a debate needs—disagreements sharp enough to define distinct positions, but not sharp enough to preclude settlement. We even have an agenda: the qualities that separate the Enlightenment from the twentieth century. By following them point by point we may determine what is living in the thought of the philosophes and what dead, what enduring and what ephemeral.

ERASMUS

An intelligent and constructive proposal! The life-blood of truth is in detail.

VOLTAIRE

You *would* think that! Detail is the pedant's refuge from thought. True, my motto was always *"Au fait!"* and I said some sharp things against metaphysicians who dealt only in words. But I never tired of protesting against the scholars of my time: those erudite pedants bored me to death.

LUCIAN

There is no danger that you, or any of us, will be bored to death now, here. You might as well submit

to the tedium of a detailed examination: it may bring clarity to your generalizations.

VOLTAIRE

If you insist. After all, clarity is never a vice.

I : ON MODERNITY

II ON HISTORY

LUCIAN

Your little diatribe against the pedants, Voltaire, tells us more about you than about them: it points to a serious defect in your mode of historical thinking.

ERASMUS

It is worse than a defect. Voltaire, you said earlier that you philosophes wrote history without falling into the extravagances of historicism. I did not believe you then, I do not believe you now: with your contempt for erudition, your tireless—and tiresome—efforts to score political points, your rage to denounce and to educate, with your judge's gown always about your shoulders, did you really write history at all?

Are you suggesting that one must give up one's moral convictions before one can be a good historian? Are you equating history with the historicists, reading everyone else, including us, out of court? That canard goes back more than a century, to Ranke.

ERASMUS

I am not fond of Ranke; he treated me as a mere precursor of his countryman Luther, when every impartial observer knows that Luther was merely a coarse imitator of mine who did what imitators usually do: take a great idea and ruin it. Ranke must have been a Lutheran.

VOLTAIRE

He was—to his bones. His program was shorter than Luther's but it was just as inflammatory; instead of ninety-five theses, he had one: every historical epoch is "immediate to God." I must say I would not want to be immediate to *his* God; He doubtless spoke German! But his peculiar taste apart, his point is unmistakable: if one did not write history in obedience to his doctrine, one was not writing history. Will you accept such a verdict— from such hands? Will you deny us the name of historian because we did not think like Ranke?

ERASMUS

As you denied Christian thinkers the name of philosopher because they did not think like you? No: I

shall not follow you in this. True, it does seem complacent for the historicists to see themselves at the summit to which others had aspired in vain—complacent and violating their own most cherished principle: you philosophes, living in your time, wrote the kind of history you had to write. Like it or not, you, too, were immediate to God. But, my dear Voltaire, as you know better than most, one chooses one's allies in debate not from affection, or even out of respect, but for use. Ranke's God is not my God; his history not my history. But his general principle seems to me perfectly sound: divest it of its theological language and it becomes, quite simply, a call for accuracy, for empathy, and for fairness. Your histories lacked all three. You have already confessed your indifference to accuracy; worse than that, you assimilated other periods to your own, and judged them by your standards. You did not really try to understand the past, you yoked it to your own purposes. You wrote not history but propaganda.

VOLTAIRE

My friend David Hume, the greatest historian of the eighteenth century, called ours "the historical Age," and Hume was right. Our quarrel with the pedants implied no disrespect for truth or accuracy. Indeed, one of my contemporaries listed "erudition, diligence, veracity, and scrupulous minuteness" as supreme historical virtues. What more could you want?

LUCIAN

Wait! You are quoting Gibbon here—Gibbon, whom
you have denigrated as half a pedant!

VOLTAIRE

As Erasmus suggested a moment ago, you choose
your allies where you find them, and as you need
them. After all, if Gibbon was half a pedant, he was
also half a philosophe. I claim him as a member of
my family, and thus as an appropriate witness.

LUCIAN

Mainly to his own work, I think; his history of my
time—truly a happy age, as he rightly says—amply
embodies the virtues he lists. Do *your* histories of
your time embody them?

VOLTAIRE

I like to think so. Did I not say, "We need the truth
in the smallest things"?

ERASMUS

It is the largest things that trouble me.

VOLTAIRE

By insisting on the truth in the one I surely insisted
on the truth in the other as well. But stay with
Gibbon for a moment: a movement that produced
a historian of such transcendent merit cannot
simply be written off as unhistorical. And Gibbon
was not unique or even exceptional; he had splendid
company. David Hume, who demonstrated his im-

partiality by arousing all parties against him, was a masterly historian. So was William Robertson.

LUCIAN

And so were you?

VOLTAIRE

To deny it would be to do violence to the scrupulous accuracy you prize so much! Even if I had my doubts about parts of Gibbon's list—especially about minuteness—I, like my fellow historians, aspired to make history into a science, and insisted that it must be neither a satire nor a panegyric.

LUCIAN

By harboring such exalted ambitions, you impose stringent standards on your work, and open yourself to the reproach that your performance did not match your professions.

VOLTAIRE

I would admit the force of that reproach, if only because, as I must insist, we philosophes were human. It is man's lot to fall short of his ideals. But even if we did not realize our program, it was a good target to shoot at. We wanted truth, but without tedium. You should look at those historical compilations that drove us into fits of impatience. They would have had the same effect on you—they *did* have the same effect on you, to judge by some of your most sarcastic writings. You gentlemen both delight in the amusing formulation and the pointed aphorism. You could no more turn up an aphorism

in these swollen monstrosities or find cause for a moment's amusement than you could find gold by sifting the sands on the Dutch shore. These tomes were dry, turgid, hideously boring and almost literally interminable; they were freighted down with trivia, with gossip, with insignificant detail, with petty professional disputes and long passages culled from earlier pedants—bores standing on the shoulders of bores—with meticulous descriptions of unmemorable battles and still more unmemorable court ceremonies, all obsessively ordered either chronologically or alphabetically, and intolerably disfigured by the grossest superstition.

ERASMUS

I see: you despised the "pedants" not so much because they were scholars, but because they were Christians.

VOLTAIRE

We despised them because they were both pedants *and* Christians. We rebelled in the name of reason quite as much as in the name of literature. And I do not think that the conjunction of pedantry and superstition was accidental: had these bookish worms ever lifted their eyes off the page, had they been less slavish about copying their authorities, they might have been more rational—that is to say, less Christian—historians. Besides, if they did much for us, we did much for them: we showed our gratitude by naming them in our histories, thus giving them an immortality they could never have achieved by themselves.

ERASMUS

A wry kind of gratitude—I recall Gibbon's cynical and condescending tributes to Christian scholars without whom he would have been helpless. And a deplorable kind of immortality—you exploited pious chroniclers in the service of unbelief, and then abused them for their pains.

VOLTAIRE

We exploited and abused Christian scholars, yes, but I insist that we did not neglect what we detested. I know that I and my fellow historians found the long hours—no, long years!—we spent in the company of Christian compilers chilling but not unprofitable. We used them and our histories show it. If our performance did not match our professions about truth and scholarship, we might also claim, a little paradoxically, that the opposite was true as well: in the light of the sharp things we said against the monks and priests we pillaged and patronized, our performance was often better than our pronouncements.

LUCIAN

That, I think, is a fair conclusion. But our criticism must stand: you enlightened historians were consumers but not producers of scholarship. You made few discoveries of new historical materials, you deciphered few documents, you invented few techniques of research. In your reading of the evidence, you were neither antiscientific nor exactly unscientific, but by failing to promote history as a

LUCIAN

That would be unjust. But if you were scientists, you were casual and irresponsible, almost inadvertent scientists: you desired the ends but despised the means.

ERASMUS

In itself this would be a weighty criticism of you Enlightenment historians. But it would hardly damage your claim that you were a historical movement presiding over a historical century. What is far more damaging, I think, is your lack of historical empathy. You treated all past epochs as though they were little editions, or unsatisfactory anticipations, of your own. You set out on your voyages of historical discovery with ostentatious preparations—kings financed, bishops blessed, and the public applauded your great enterprises. And you brought back shining trophies which guaranteed your fame by satisfying your admirers. It was only when they inspected those trophies a little more closely that the truth really came out: you had bought them—cheaply—at home. You even supplied your unhistorical attitude with a theoretical justification and sacrificed the wealth of human experience in the past. Remember what your friend David Hume said: "It is universally acknowledged, that there is a great uniformity among the actions of men, in all nations and ages, and that human nature remains still the same, in its principles and operations. The same motives always produce the same actions." Believing this, how could he help concluding that "Mankind are so much the same,

technical discipline you slowed its development toward science. You forgot, or perhaps never knew, that the instruments of the historian's craft grow dull and rusty with disuse. I do not wonder that your successors—Niebuhr and Ranke and the others —should hold you in low esteem.

VOLTAIRE

I can accept your specific criticism, but I must reject your general conclusion. We did promote the science of history: we were, in fact, the first scientific historians. We broadened the very subject matter of history to culture itself. We made causation a subject of scientific historical study by taking it away from the theologians. We destroyed legends.

ERASMUS

You conveniently forget that it was Mabillon and other "superstitious pedants" who did most of this destructive work for you, discrediting forged documents, discriminating between reliable and unreliable evidence.

VOLTAIRE

There was one legend, the greatest and most dangerous legend, they left undisturbed: supernatural religion. Have you ever read Bossuet's history of the world, all ordered by religious events and dominated by divine interventions? Bossuet was a great writer but a great fool. We made such foolishness impossible. That, I think, was a great deal. Will you now denigrate our contribution to the science of history because we did not do everything?

in all times and places, that history informs us of nothing new or strange in this particular"?

VOLTAIRE

I am glad you quoted this passage.

ERASMUS

Whenever in the course of a debate someone says, "I am glad you quoted this passage," or, "I am glad you asked that question," he really means, "I am sorry; you have confounded me."

VOLTAIRE

Not at all. I am happy to meet this issue head on. You have quoted Hume correctly. And Hume meant precisely what he said. But his observation has been made to serve, long and hard, purposes for which it was not intended; it is a racehorse bullied and beaten and loaded down as though it were a draft animal without any breeding.

ERASMUS

Picturesque but unresponsive. Say, rather, that Hume's view of man—which, I take it, is the Enlightenment's view of man—is an unscalable wall between your philosophy and the historical mentality, for if there is nothing new or strange in the world, where are novelty, uniqueness, variety—all of them the very lifeblood of history?

VOLTAIRE

A wall is a metaphor quite as much as a horse, with or without breeding, though less elegant and less

happy. The doctrine of a uniform human nature is a time-honored doctrine; it goes back to classical times, and has survived, in one form or another, into the twentieth century. Freud, I believe, held to it. You accepted it, Erasmus; and so, Lucian, did you. Were there no historians in the sixteenth or in the second century of our Lord? Thucydides, the greatest of historians, had his doubts about the barbarians, but his greatness did not rest on those doubts. Tacitus worked with that theory, as did St. Augustine, and if both had grievous faults as historians, it was not because they believed in the uniformity of human nature, but because they were wrong about the *kind* of uniformity they believed in. Surely the history of history must enter into the definition of history; that definition cannot be exhausted by what the craft has become in, and since, the nineteenth century. I cannot say it often enough: it is absurd to equate history with historicism. If I had to choose the elements essential to a true historian at all times, I should choose independence of spirit, and the critical capacity to see, and by seeing remove, the fetters to such independence, for some of those fetters are subtle, invisible. My ideal historian, in other words, is fearless, incorruptible, frank, truthful; he calls a spade a spade, spares no man out of pity or false respect for the proprieties; he is an impartial judge, kind to all but too kind to no one; a cosmopolitan who heeds no man and acknowledges no sovereign but himself; a free spirit who simply sets down what happened.

LUCIAN

Well! First you quote Gibbon against us, now you quote me. Do you think I have forgotten my own writings?

VOLTAIRE

What better authority could I appeal to than you?

LUCIAN

If you accept my authority, you will agree with me that the historicists' insistence on historical uniqueness and their dissolution of human nature in behalf of historical diversity has had enormous utility for the historian—far greater than *your* theory of man.

VOLTAIRE

I am happy to quote you, less happy to accept your verdict. In its extreme form the historicist view of man is false as psychology and pernicious in what it implies about historians who predate or reject their work. In its moderate form it is true enough, but then it is not a revelation to us: we enlightened historians knew it all perfectly well a hundred years before Ranke.

LUCIAN

You are falling into your old habit: you claim too much for yourself. The historicists' critique served as a kind of pointer; it was an invitation to respect the almost infinite variety of man's experience.

We respected it quite as much as the historicists
did. . . . Well, perhaps not, but quite as much as was
necessary. Whatever you may think, our psychology
in no way prevented us from respecting it.

LUCIAN

That is precisely the point that needs to be demon-
strated. *Au fait!* Let us turn to the facts—as you
would say.

VOLTAIRE

Let us turn to the texts—as the scholars would say.
This is how we saw it: man has been, from the begin-
ning of time, equipped with certain elemental
passions. They have never changed and never will
change. The longing for fame or fortune, the love
of self and others, the mingled desire for and dread
of the unfamiliar, of the forbidden, and of death,
a powerful, normally well-concealed sensuality—all
these are the permanent building blocks of man, of
the ancient Egyptian as of the modern Frenchman
as of the future citizen of the world. Some forms of
"ambition, avarice, self-love, vanity, friendship,
generosity," Hume said, have always been, and
continue to be, "the sources of all the actions and
enterprizes, which have ever been observed among
mankind." I will grant that the list of the essential,
enduring human qualities differed a little from
philosophe to philosophe, but the differences were
(shall I say?) at the margins of man, not at his

center. You must remember that psychology was a young science in our day—in fact, we invented it.

ERASMUS

The study of man's soul is much older than the Enlightenment. You invented the word "psychology," not the discipline.

VOLTAIRE

We invented both. Our precursors, especially the pagan moralists of antiquity, had some amusing and acute insights into the springs of human conduct. But precisely because they studied the soul, they were not really psychologists. It was not until Locke taught philosophers to do without the soul, that unknowable and irrelevant metaphysical entity, that the real science of man became possible. That is why we were the fathers of psychology, as of so much else in the modern world.

ERASMUS

You are certainly a living demonstration that self-love is a prominent ingredient in man. But tell me: How do you get from your stable catalogue to historical diversity?

VOLTAIRE

The unchanging qualities of human nature are, so to speak, its raw material; they can be combined in the most amazing variety of ways. Nor is this all: each quality has many faces: the pride or the benevolence of an ancient Greek is not like the pride or the benevolence of a modern Englishman. As Hume said, "Mighty revolutions have happened

in human affairs," and "Those, who consider the periods and revolutions of human kind, as represented in history, are entertained with a spectacle full of pleasure and variety." His appetite, and his aptness, for history, it seems to me, could hardly have been greater.

ERASMUS

I grant you the appetite; I am not so sure about the aptness. Hume's view of man strikes me less as convincing than as convenient. What it takes away with one hand, it restores with the other. At one moment Hume professes to find nothing new in history; at the next he professes himself to be full of surprise at the varied spectacle—the bored worldling has turned into the wide-eyed child.

VOLTAIRE

You are like all our critics: first you misunderstand us—willfully, it seems to me, for we were always perfectly clear!—then you build from this misunderstanding a rickety structure you label "the Enlightenment." And then you complain about its inadequacies, and point out the flaws in its construction. You are perfectly right to complain, but you are complaining about what you made, not about what we made. I shall try again. Hume believed—as did we all—that history could teach him nothing new about human *nature*. He, and we, arrived at this conclusion only after the patient study of history, for history was, to us, human nature at work through the ages. But the quality of human nature that surprised us least was that it was full of surprises. As my singular friend Diderot

put it with his customary energy: "The heart of man is by turns a sanctuary and a sewer." Fixed in its fundamentals, man's nature expressed itself in a myriad of ways. Each passion had many styles; each epoch was unique in its combinations of passions. As Saint-Évremond put it in the seventeenth century—and he was as near to being a philosophe as anyone could be in his time: "Every age has its own character." His proof, I think, is charming: "It would be the height of absurdity to make love like Anacreon and Sappho; the extreme of middle-class stodginess to make love like Terence; the utmost in crudity to make love like Lucian." It was one of the main tasks of history to record all this variety. In fact, we philosophes were not content to record and enjoy it. We sought the laws that might underlie it; we sought them in climate and in the soil, in the size of the state or its form of government or its dominant religious worship. But to give laws to variety does not mean to deprecate or deny it.

LUCIAN

At this distance in time I am surely free of vanity, but I must protest against your proof from Saint-Évremond. You used it to show your historical awareness, but if it shows anything, it is your presumption and your ignorance. Did Saint-Évremond have the slightest idea of how I made love?

VOLTAIRE

It is a delicate question, I know. I meant nothing personal; I merely wanted to suggest that we were

aware of large differences in human conduct
through time. I might have chosen better examples.

LUCIAN

You might.

VOLTAIRE

I might have quoted Montesquieu, and Hume, and
Gibbon—and myself—at length, to show that we
made it our study to understand the laws and
customs of distant ages from their point of view,
instead of ours, and to judge the men and women
of the past with their standards. We even pleaded
for what the Germans have since come to call, in
their barbarous jargon, *Einfühlung*—a capacity
for adopting the very spirit of the age whose history
we were writing, and of entering into the very
being of historical personages, no matter how
remote. I insist: as philosophical historians, nothing
historical was alien to us.

ERASMUS

And I insist, again, that your work does not bear
out your words. You paraphrased Terence's famous
saying: nothing historical, you said, was alien to
you. I must turn it around: what was alien was
unhistorical for you. In reading your histories I
never found that you tried to enter the spirit of
Christians, or to judge foreign nations by any
standards but your own. True: you pursued the
past to remote ages and peoples, but rarely for
their own sake. Your interest in ancient China or
medieval Europe was mainly the interest of lawyers

who plow through dusty books to find precedents for their clients. China offered welcome instances of deists before your time; the Middle Ages supplied exhibits for your museum of man's wickedness and absurdity. Earlier I compared you philosophic historians to judges; I should have said hanging judges, prosecuting attorneys, angry men with a cause to plead and a case to win. Your sin against historical light is great, for you saw what had to be done and refused to do it.

LUCIAN

You were like Dante's Vergil: you held up the light for those who would follow you, but you yourselves walked in darkness.

VOLTAIRE

There is something to what you both say; I can see that. Being beyond my battles now, I am above them. Our empathy was more deficient, our reading of history more purposeful, than they should have been. But if we drew a caricature of the Middle Ages, was it not a time inviting caricature? If we piled up tales of crimes and absurdities, we only did what was right: the period was filled with both. To be silent about them—*that* would have been the real sin against history, for it would have been to suppress the truth for the sake of piety. We held the light for those who would follow us, you said. Yes, but we held it high enough, so that we, too, saw by its glow. And what is more: much of that light was of our own making.

LUCIAN

Perhaps that is true. It was with your attitude toward human nature as it was with your attitude toward scholarship: in itself it did not keep you from writing history, and good history. It was your historical battle with Christianity, indeed with the whole religious view of the world, that propelled you into partiality and special pleading.

ERASMUS

The defects of Enlightenment historiography lie deeper than special pleading: your misreadings cannot be corrected by attention to detail. It is not just a question of altering a few adjectives, of finding admirable qualities in a saint or intellectual merit in a pope. Whatever you may say about sympathy, about your willingness to use the standards of the period you were writing about, the fact is you never got inside Christians, Christianity, or Christian centuries. You quite simply failed to see, and, worse, kept others from seeing, the shape of medieval life, the realism of its dreamers, the philosophical quality of its theology, the wealth of its worldly culture, the tensions that made it much like life both before and after it. It was a grim age: I said so in my time, and historians after you have said it as well. But it was a real civilization, rich and alive, with possibilities for change concealed in its very rigidity. I said you failed to see all this. It was worse: you *refused* to see it.

I am willing to acknowledge now what I should have denied in my time. But why dwell on our deficiencies, real as they were, and pass over our merits in silence? They were real as well.

ERASMUS

Because you concentrate on your merits to conceal your deficiencies.

VOLTAIRE

But our merits remain worthy of note. In some critical respects, our worst liability was our strongest asset. Our fundamental quarrel with superstition—our aggressive secularism, if you like—gave us the perception and the energy to transform historical study into a secular discipline. If we were not always sufficiently critical of ourselves, we at least opened all of the past to the cool view of criticism. Before us, pious historians had averted their eyes from the sanctuary; even Mabillon, on whom you set so much store, was credulous to a degree. We entered the sanctuary with our eyes open and our shoes on.

ERASMUS

So you did, and to do so was impious, brutal, and destructive.

VOLTAIRE

You call us impious: a charge I delight in. You call us brutal: I reply that if you are threatened by

a wild beast, you must kill it. You call us destructive; I have said it before, and shall always say it: one must destroy in order to build and, besides, what we destroyed was not worth preserving. Reverence for the unworthy is a sign not of respect but of slavery. Look at the benefits our impiety, our brutality, our destructiveness brought to the study of history. By eliminating God as an active historical cause, we opened the vast field of historical causation to scientific inquiry and subjected the intricate question of historical periodization to internal—that is to say, historical—tests. As long as God was in history, theologians could prove anything: the travail of God's children, or their triumphs, could all be used with equal plausibility— that is to say, implausibility—as evidence for His activity in the world. As long as God was in history, insignificant, irrelevant, or imaginary events, like the building of the Tower of Babel, or the expulsion from Paradise, presided over historical periods, instead of decisive events, like the migration of peoples, the invention of gunpowder, or the reign of Louis XIV. We changed all this, and this change is one of the great revolutions in the history of history.

LUCIAN

Great, but incomplete.

VOLTAIRE

Of course, like all revolutions.

ERASMUS

Your modesty becomes you, but you wear your fallibility like a badge of honor; no—like a cloak of immunity. Your strategy is simple but in the long run self-defeating: when you find that you cannot refute a criticism, you wrap yourself in it as proof of your humanity.

VOLTAIRE

(after a long silence)

You have done something, Erasmus, that few men have succeeded in doing: you have reduced me to speechlessness.

ERASMUS

Not, I am sure, for long. Your dogmatism, which you disguise as sincerity, and your ignorance, which you disguise as empiricism, will soon restore your fluency.

VOLTAIRE

There are moments when I could learn to hate you, with your pious heartlessness, your Christian smugness. You have drawn blood; must you twist your rapier in my wound? I confess it: we often sought to have the best of all arguments; we feigned certainty when we felt only doubt. Do you think this was nothing more than facility, light-hearted irresponsibility, the mania for winning debates? Do you think it was a small thing to over-throw the beliefs of centuries, to reject our fathers in the name of a philosophy we had to patch together

from antique remnants, or had to invent as we went along? Some of us were lucky: we were led into unbelief gently, by easy stages, or lived in a world where unbelief was already a familiar guest. But for most of us the conquest of philosophy was a difficult, lifelong inner combat. It may not be surprising that Lessing should be haunted all his life by the faith of his fathers. But even Diderot—all his life—had moments of unbelief in his unbelief, and I often cursed my urbane skepticism that excluded me from the cheerful, simple-minded fellowship of pious men and from their consoling belief in immortality. We were wits, and our wit was the despair of our enemies, but it was also, often enough, a cloak for our own despair. In public we dazzled everyone, in private we bit our lips in our pain and our isolation. I see from your face that you do not believe me, but you can believe me if I tell you that you doubt my report only because you do not know our life histories. And you know nothing of the penalties of autonomy, those recurrent pangs of nostalgia, uncertainty, and emptiness. They are as bad as the dry spells of the mystic, when his vision clouds over, and his God is silent. We philosophes were a family because we found one another's company delightful and instructive, and because we all were doing the same thing, which is of all firm bonds one of the firmest. But we were a family also because we needed one another for comfort, for mutual confirmation. Often we were deeply disheartened, and wrestled with dark questions about our very mission in the world.

ERASMUS

(after more silence)

I could wish that your fit of depression would last for a while; it might convert the modesty of which you like to boast into true humility. But, lasting or fleeting, your outburst does you honor: up to now you have merely claimed to be human, to disarm criticism. Now you have shown that you are.

LUCIAN

I never thought that I would have to defend you against yourself. But let me bring you back to your customary cheerfulness—and to our theme. I agreed that the Enlightenment had made a revolution in the writing, the very conception, of history, but—

VOLTAIRE

I did not even have the opportunity of describing the full range of that revolution. By secularizing historical causation we burst the boundaries of Christian history in all its dimensions—in breadth, in time, in depth. We could take an interest in the history of Oriental cultures, and not as the unhappy beneficiaries of missionaries alone. In proving that the world is far older than the Bible seems to allow—and the Bible is self-contradictory on this point as it is on everything—we could give adequate room to the history of ancient civilizations. And by pushing aside the veils of devotion, we could extend our view to culture as a whole, not merely to the history of love-making where the evidence, though piquant, is scarce, but to that of state-

making, and literature, and manners in general. That is why our historical masterpieces are monuments in the history of history.

ERASMUS

I did not think it would take you long to regain your pride. "Monuments" is a good word, if you take it in the sense of gravestone. Who in the twentieth century reads your *Siècle de Louis XIV?* The student of French literature perhaps, not the student of Louis XIV. Who now reads Gibbon's *Decline and Fall of the Roman Empire?* The student of eighteenth-century England, perhaps, not the student of Caesar Augustus. And who reads Hume's *History of England?* Nobody.

VOLTAIRE

Say milestone rather than gravestone. I must insist that we saw history as part of the science of society, a science which, like all sciences, must progress. We took pleasure in such progress, even if our own work has been partially eclipsed in the process.

ERASMUS

You *are* incurable.

LUCIAN

If I may interrupt your interruptions long enough to make my point: what seems to me incomplete about the Enlightenment's revolution in historical writing, and what gives the most masterly of your eighteenth-century histories an air of quaintness

and even naïveté, is, first of all, the lightheartedness, the simplicity, with which you derived great historical events—epoch-making revolutions and reverberating catastrophes—from trivial causes, from the invention, or the intention, of one man, or a few men. You badly scanted the operations of majestic impersonal forces, and the unintended consequences of men's actions. You expressed curiosity about population, about the growth of cities, about economic developments, but you left it at that. And besides: your historical dramas lack the stature and the subtlety of tragedy; all too often they read like morality tales in which good men battle villains, in which issues are obvious, sharply drawn, quickly perceived. If men have learned anything since the eighteenth century, it is that life—and, with that, history—is complicated.

VOLTAIRE

I am sorry to appear to be quibbling, but I can accept your criticisms only in part. You must admit that to secularize historical cause was no small matter. Our expulsion of God left us with a gigantic task or set of tasks. How *did* empires rise and fall, if it was not part of God's scheme? Why *did* the English rebel against James II, if that was not God's will? Why *did* Luther appear when he did, and have the success he did, if this was not, as the Romans said, divine punishment, or, as the Protestants said, divine favor? We searched, we labored, we faltered, we contradicted one another and ourselves. D'Alembert thought that the revival of letters, which men have since come to call the

Renaissance, was the work of the Greek scholars driven to Venice by the fall of Constantinople. My own explanation of that great revolution in human affairs was far more complicated, and far more adequate, than d'Alembert's.

ERASMUS

But—as I have good reason to know—not complicated enough, and hence not adequate.

VOLTAIRE

Very well: not complicated enough, and not adequate. And on your second point, Lucian, as on your first, I must plead the magnitude and novelty of our task, thrust upon us in the midst, and for the sake, of our great war against superstition everywhere. In delineating great historical personages, we had to invent a whole new vocabulary, and we often used the old familiar language, the language of morality, when we were drawing a psychological portrait. May I quote you David Hume on Charles I of England? "The character of this prince, as that of most men, if not of all men, was mixed; but his virtues predominated extremely above his vices, or, more properly speaking, his imperfections; for scarce any of his faults rose to that pitch as to merit the appellation of vices. To consider him in the most favorable light, it may be affirmed, that his dignity was free from pride, his humanity from weakness, his bravery from rashness, his temperance from austerity, his frugality from avarice; all these virtues in him maintained their proper bounds and merited unreserved praise. To speak

the most harshly of him, we may affirm, that many of his good qualities were attended with some latent frailty, which, though seemingly inconsiderable, was able, when seconded by the extreme malevolence of his fortune, to disappoint—"

ERASMUS

Enough. You have made your point. We have touched all points of the compass, and we must move on. Let us grant that you made important contributions to the writing of history, and that the splendid books of nineteenth-century historians built on your efforts. But like it or not, the verdict is clear: you did not reach the heights the historicists reached. That should be enough for you. Next subject!

VOLTAIRE

I did not know we had elected you chairman of our discussion.

LUCIAN

We are, in fact, not yet done. You will remember we agreed to determine not merely what the Enlightenment meant in itself, but also what it meant, or could mean, to the twentieth century.

VOLTAIRE

Yes. The champion of the Enlightenment has two tasks, clearly: before he can show that its ideas remain relevant, he must rescue them from two centuries of interpretation.

ERASMUS

To know you is to imitate you?

VOLTAIRE

We never asked for disciples. As you said so well,
Erasmus, in your day: those Humanists who in-
sisted on copying Cicero word for word did not
perpetuate his spirit, but did violence to it, for
Cicero was always himself.

ERASMUS

I shall not accept flattery as a substitute for demon-
stration.

VOLTAIRE

I offered the flattery only because I thought it
might smooth the way for demonstration.

ERASMUS

Well, so far you have demonstrated only that your
kind of historical thinking has no relevance to the
twentieth century at all.

VOLTAIRE

You are in an indecent haste to bury us before we
are dead. There is one part of our legacy in the
writing of history that is much despised today, and
should be despised less: our moral judgments. As
I have said before: we thought of the study of his-
tory as one branch of a comprehensive science of
man—intimately related to, drawing on, and in
turn serving psychology, political economy, and

the science of society. This science of man, we thought, had two purposes so closely intertwined that the one could not live without the other. It was to satisfy the appetite for knowledge—that was Castor; and serve the demand for human betterment—that was Pollux. To be sure, the pursuit of knowledge even for its own sake is moral: it postulates the choice of wisdom over foolishness, truth over falsehood. And this moral postulate alone compelled us to be hostile to Christianity: we interpreted the story of the Fall as a punishment for the longing to know. We thought that God, far from expelling our first ancestors from Paradise for their audacity, should have rewarded them for it. But we were not content with such an abstract argument: we were never content with abstract arguments. We thought knowledge a virtue because it was subversive; subversive of error, sham, arrogance, self-deception, and above all of the calculated deceptions the rich feed to the poor to keep them poor, and the powerful to the impotent to keep them impotent. We could not conceive the science of man in isolation from the clash of interests, the struggle of parties, the pursuit of scarce resources.

LUCIAN

But you wanted history to be a science!

VOLTAIRE

The call to make history scientific was realistic enough. By scientific we did not mean the science of the laboratory, the reduction of historical facts

to quantities or to universal laws. We meant the subjection of historical assertions to continuous and disciplined criticism at the hand of all the auxiliaries the historian could muster. But the call to make history neutral is a form of self-deception, or, perhaps, part of that conspiracy against the common good that lies at the heart of so much resistance to change. History is never neutral; if it is not critical, it is conformist. It may appear to be neutral, but that neutrality is only a subtle version of conformity.

LUCIAN

Very well. But even if moral judgments belong in history more than modern historians have been willing to grant, your histories are an unwitting demonstration of how such judgments should not be made. They were too strident, too simple, too important to you, to produce the kind of comprehension for which modern historians strive. Your conclusions were often an inevitable, wholly predictable consequence of your moral position. Far from permitting your reading of history to render your moral judgments more flexible, your moral judgments compelled your history to be more rigid. You have quoted from Hume's *History of England* for your purposes; let me quote him for mine: "The most barefaced acts of tyranny and oppression were practised against the Jews, who were entirely out of the protection of law, were extremely odious from the bigotry of the people, and were abandoned to the immeasurable rapacity of the king and his ministers." Again: "Interest had in

that age mounted to an enormous height, as might be expected from the barbarism of the times and men's ignorance of commerce. Instances occur of fifty *per cent.* paid for money. . . . Such profits tempted the Jews to remain in the kingdom, notwithstanding the grievous oppressions to which, from the prevalent bigotry and rapine of the age, they were continually exposed. . . . To give a better pretence for extortions, the improbable and absurd accusation, which has been at different times advanced against that nation, was revived in England, that they had crucified a child in derision of the sufferings of Christ. . . . Though these acts of violence against the Jews proceeded much from bigotry, they were still more derived from avidity and rapine." And, as Hume shows in some detail, King Edward led in these persecutions, driven on by his "ill-judged zeal for Christianity," and by his "rapacity."

VOLTAIRE

What is lost by Hume's righteous, enlightened indignation? What is lost by calling the times and the men by their right names, exposing them as barbaric, bigoted, rapacious? What is lost? Nothing. What is gained? Much. Hume's philosophical convictions served him as instruments of perception; they permitted him to probe beneath the surface of events—the usurious rates charged by the Jews, their odious profiteering—to their causes. And Hume's convictions served him, as well, as an aid to enlarging his humanity, to rise above any paro-

chial prejudice in behalf of his coreligionists to a comprehensive human sympathy.

LUCIAN

I grant the gain; I deny there was no loss. Hume can detect the causes of the Jews' usuriousness; he is helpless before the causes of anti-Jewish feeling. By judging a particular situation from a universal moral position, he misses in Christian culture what you all missed: the strains, the anxieties, the very humanness of its life.

VOLTAIRE

Perhaps modern historians can make distinctions we could not make because with us things were not yet so distinct. Perhaps it is less the quality of history-writing that has changed than the range of the historian. The twentieth-century historian is far more of a technician than we could hope to be. We were far more philosophical than he could hope to be. We lost something by the change; so has he.

LUCIAN

If you had to choose between being a historian and a philosopher, which would you choose? . . . No reply?

VOLTAIRE

My silence was my reply. In the Enlightenment the choice would not have arisen. That it has arisen now is one of the darker sides of modernity.

III ON OPTIMISM

LUCIAN

Your sense of modernity, Voltaire, as a mixture of light and darkness has inspired me to invent an ancient Greek myth. Long, long ago, before there were any cities, before there was writing, when men lived much like the animals of the fields, there was little intercourse between gods and mortals. Driven by lust or tedium, Zeus or Aphrodite would come down to earth to seek some favorite partner, and the consequences of those encounters were always the same: another demigod, to enrich the natural order and to complicate divine family life. One evening in that distant time, when Zeus happened to be bored with adultery, and Hera with berating him for it, these two gods sat down together peaceably and had one of their rare conversations. They looked at the earth stretched out below them, and their talk turned to that most

unsatisfactory, most contradictory, of creatures —man. "There he is," said Zeus, musing. "So godlike in appearance, so appealing in his exceptional physical specimens, yet so beastly in his ignorance, his filth, his total lack of cultivation. How tedious is man." Hera, glad of Zeus' unaccustomed company, agreed. "Let us do something about him," Zeus said. "Let us find some young man, as handsome as Ganymede, and some young woman, as beautiful as . . . er . . . you, bring them to Olympus and teach them that there is more to life than eating, sleeping, and fornicating. Let us give them curiosity—about us, about themselves, about the world in which they live. Let us teach them how to read and write, to adorn themselves and their surroundings, to play, to congregate with others in orderly assemblies, and to store up wisdom."

Hera complied. After some search, she found a strapping young shepherd and a lovely young shepherdess, and took them to the dwelling of the gods. With the aid of the other gods, each imparting his special knowledge, she taught them arts, sciences, and literature. The young couple were apt, quick-witted pupils, and before long they were godlike in more than appearance, though always conscious of the gulf between them and their preceptors— more conscious, indeed, than they had been before they had begun their education. Before, they had not thought of death; now they became aware of the weight of mortality. But this made them only more thoughtful than ever. When they began to spin myths, often of surprising originality, about life and death, about the meaning of existence, and even

about the birth of the gods, Zeus and Hera judged that the lessons were ended. They sent their pupils back to earth, and watched them, with pleasure, as they founded a family, gathered a society, and started a dynasty, as they built a city and a culture, complete with efforts at natural science and local history.

Then something strange happened. The couple were so responsible, and so intelligent, that the gods, with their unchecked sensuality, their stupid drinking bouts, their acrimonious quarrels, seemed actually inferior to what they had fondly described to themselves as their creatures. Feeling uncomfortable, and in some way tricked, the gods became jealous. The creature, it was painfully obvious, had somehow outstripped its creator. Of course that one ineluctable point of superiority of gods over man always remained: they were immortal, he mortal. Man could deny the gods, but not destroy them; the gods could destroy man. And Zeus and Hera, no longer bored but profoundly uneasy, decided to rid themselves of the couple they had singled out for education with such ambiguous success. They invited them up to Olympus and sat them down to a sumptuous feast in the company of all the gods. Then, with divine distance, Zeus announced to them their imminent end.

The woman was resigned. "Let death come," she said, "it must come to us anyway. At least let us bear it well. It is not everyone to whom the gods pay such personal attention as to us." But her husband was more rebellious. Having made up some philosophy for himself, he determined to use

it in this critical hour. "You made us what we are today," he told the gods. "We are your greatest handiwork precisely because we are no longer acting as your handiwork. Your world is full of slaves. Thanks to you, we are free men. To kill us is to kill the best in you, to kill something you need to keep from dying of ennui in your eternity: we have become the only animal that is really interesting."

The gods are jealous—this is one of their few stable traits—but it also amuses them to display their compassion . . . sometimes. Zeus was moved, and even partly persuaded, by the shepherd's plea, and announced that he would spare his pupils' lives. But what punishment, then, should be meted out to mortals who had made the gods feel just a little silly? After some discussion, Zeus found the appropriate sentence. The thing to do was to deprive these humans of what they had learned at Olympus and then fashioned on earth, and to restore them to their old condition, to their former rustic stupidity.

This was promptly done, and for a short while shepherd and shepherdess vegetated as they had done before, steeped in filth and bestiality, seeking their pleasures in the open air. But then another strange thing happened. The gods may be powerful, but they are not omnipotent. What they had made, it turned out, they could not wholly unmake; the appetite for work, learning, and beauty they had awakened in these miserable humans continued to flicker, like a tiny flame, in shepherd and shepherdess. At first, they were only uneasy; soon they became unhappy, feeling some great loss and some great need. With painful effort—as men who have

broken their limbs learn to walk again as if they were small children—they came to recognize that they had been robbed of some very precious things. Slowly, with many false starts and after many disheartening moments, they succeeded in reconstructing what had happened. And so they went to Zeus and begged him to give them back their learning, that they might again exercise their intelligence. Zeus heard them out with unaccustomed gravity, and then warned them, just as gravely, that he might give them what they wanted—to their eternal regret. "Nothing will come easily to you," he said. "You will find responsibility a heavy burden on you. You will find that every bright new invention has its shadow side; that your conquests will often enough be illusory; that you will know more only to feel less, permit yourselves greater hopes only to experience greater disappointments. Just as we discovered that we could not restore your original innocence, but merely give you back your ignorance without your peace of mind, you will discover that the innocence and ignorance you long for will no longer be possible to you, no matter how hard you try."

Shepherd and shepherdess listened politely, patiently, but their minds were made up. They insisted that civilization was worth the cost, and the gods gave them their wish. The couple departed from Olympus hand in hand, safe, yet laden down with their knowledge. And ever since then every advance has meant a retreat, all progress has caused new, hitherto unimagined difficulties, all that is good in life on earth has been bought at an exorbitant price. The historical work of the Enlightenment, with its

achievements and its failures, illustrates the truth of my myth.

ERASMUS

A charming fable with a worthy moral. It might have done the philosophes some good; it might have made them a little less naïve, a little less optimistic, than they were.

VOLTAIRE

We philosophes optimistic! This is the oldest, and remains the most persistent, slander against the Enlightenment. If we were optimists at all, we were not fatuous ones. Have you ever read the *Lettres Persanes* of Montesquieu? or the essays of Hume? or the political dialogues of Wieland—even those he wrote before the French Revolution which so frightened poor little Gibbon? or the essay on progress by my unfortunate young friend Condorcet? He was, I suppose, the greatest optimist among us all—his hopes were swollen and, I fear, a little unphilosophical—but even he had a keen eye for the sufferings of the past, the inadequacies of the present, and the inescapable limitations on the future. Have you, for that matter, read *me?* "If this is the best of all possible worlds, what are the others like?" is, among all my remarks, my favorite.

ERASMUS

You will never persuade me that you and your Enlightenment are innocent of fathering the pernicious theory of progress—

LUCIAN

Fathering? The idea of progress was an invention of Christian dreamers; there were, through the centuries, Christian optimists who saw the course of man's life as a progress toward redemption. Only we pagans knew how to be true pessimists.

ERASMUS

Well, if not fathering, at least encouraging: the theory of progress made progress only in the Enlightenment. After two thousand years of sensible and appropriate seriousness—broken occasionally by mystical exaltation—the Enlightenment turned men's minds to foolish notions of original innocence, foolish confidence in man's capacity to reform himself and his institutions, in a word, foolish optimism. I have long enjoyed your *Candide*, Voltaire, like everyone else—have I not told you? I much admire your fictions—but you cannot make me believe that the despairing cry you put into Candide's mouth represents a dominant, or even prominent, mood in your movement, or even in yourself. If we were to take responsibility for everything we make our dramatic creations say, there would be an end to literature.

VOLTAIRE

I would feel easier about your ambiguous compliment to my fictions if you did not insist on classifying as fictions what I offered as objective reporting or truthful history. I need hardly tell you that, like you, I reject the vulgar kind of

reading that identifies the literary creator with his creatures. But, unlike you, I am sure that what we believed—like the original innocence of man—was not foolish; and what was foolish—like the theory of inevitable progress—we did not believe. If I did not exclaim over your delightful fable, Lucian, that was not because I did not enjoy it, but because it taught me nothing new. Lucian's fable—and other stories, like the myth of Prometheus, and Herodotus' story about King Croesus—illustrates in dramatic form something that we, in the Enlightenment, firmly believed about the way of the world. Let me call it, for want of a better term, the law of compensation. We all believed, more or less strongly, that culture reaches a certain peak and then inevitably declines.

LUCIAN

Don't tell me you believed in the historical cycles we ancients believed in. I should have thought that you would have scorned them as just another antique superstition.

VOLTAIRE

We did not have a theory of historical cycles—we really had no historical theories of that kind at all. We simply saw an ebb and flow in experience. "Everything has its limits," I said. "Genius has but one century; after that, everything must degenerate." And Hume said, "No advantages in this world are pure and unmixed." And Montesquieu said it before us all: "Almost all the nations of the world travel this circle: to begin with, they are barbarous; they become conquerors

and civilized nations; this civilization permits them to grow, and they become refined; refinement enfeebles them, and they return to barbarism." Do you want more? I could quote Condillac, or Wieland—by the hour—or Kant on the heavy price of progress, on the dubious quality of all advances, on the slowness and difficulty with which every step toward civilization must be fought for, and on the ease with which civilization retreats. But I think I have made my point.

ERASMUS

Your quotations are impressive but not convincing. After all, you did get the reputation of being optimists—you yourself call it the oldest and most persistent slander against you—and you cannot explain away the near-unanimity of your critics as partisanship, malice, or sheer ignorance.

LUCIAN

Erasmus is right, Voltaire. So many readers cannot be simply, certainly not wholly, wrong.

VOLTAIRE

But the evidence I gave you cannot be simply, or wholly, wrong either.

ERASMUS

I accept it for what it is worth. I only doubt that it is worth much. You conveniently forgot to quote the philosophe—our friend Gibbon—who said that it is unlikely that civilization will ever relapse into its original barbarism, or the philosophe—your friend Diderot—who said that culture might change

countries but would never decline, or the philosophes—and there were many—who said that ultimately reason and humanity would win out.

VOLTAIRE

Lucian anticipated my answer: the Enlightenment did not believe in cycles. We believed, with Lucian's shepherd and shepherdess, that progress is slow and hard, but that it is possible and always worth working for. We understood that the pace, the quality, of progress have varied from time to time and from place to place, and that there were decades, sometimes long centuries, when there was no progress at all. We knew that even when there *was* progress, it was never the automatic working of fate, or a gift of the gods, or a chimera dangling before men's infatuated eyes, but the fruit of labor and of thought. In fact, it was philosophies like ours that made progress possible—it is precisely this conviction that gave our thought its energy. In general, we in the Enlightenment did not subscribe to theories of progress at all—Turgot and Condorcet, often called representative, were exceptions—but we saw enough progress in history to give us heart; and we expected progress in the future, provided that men followed our methods and adopted our goals. If you must call us optimists, call us moderate, skeptical optimists.

LUCIAN

Well, be candid: looking back on your time from the perspective of two centuries and with the detachment of an immortal, do you find that even in

your "moderate, skeptical optimism" you were, so to speak, not moderate enough?

VOLTAIRE

I confess I am torn between what I now see and what I still hope. I take comfort in the implausibility of truth. Does not science teach us to distrust the reports of our senses, and our observation? Common sense shows that the sun moves round the earth, science demonstrates that common sense is wrong. Observation shows that the world today is a miserable pile of mud, a sink of stupidity and crime, a wearisome catalogue of missed opportunities, but may not the sciences of man and society eventually prove this observation wrong? What we are witnessing in the twentieth century may be an aberration, the panicked response to overly rapid change, the detour that will eventually lead to the straight way, the last supreme effort by the mortally wounded beast of unreason.

ERASMUS

Your faith in progress remains as touching today as it was two hundred years ago. Admit it: the most thoughtful are rejecting your facile philosophy of hope and taking on the heavy burden of despair.

VOLTAIRE

I see nothing heavy in that burden—it is not a sign of insight but a symptom of self-indulgence. It is always easier to despair than to hope. Despair is a form of laziness.

That is shallow psychology; say, rather, laziness is a form of despair. Inaction is the appropriate response to a hopeless situation. If we were pessimists in antiquity, that was because we lived in circumstances in which the world had power over us, and we little power over the world. If men in the twentieth century are pessimists once again—and doubly pessimists, having in their memories the fair shape of hope—it is for the same reason.

VOLTAIRE

But just as you were pessimists because your time would let you be nothing else, we were men of good hope because our time urged hope upon us. We were cheered by progress in science, in manners, in humaneness, in knowledge, and by what appeared to be progress in medicine. Best of all, as men of letters we took the improvement in the condition of literary men—we were freer, wealthier, more respectable than our predecessors—as indicative of a general improvement. For us in the Enlightenment, progress was an experience before it became a program. And this, just by the way, confirms the claim we have always made: we were realistic interpreters of our time.

LUCIAN

Even if that were true, you were in any case unsuccessful prophets. Moderate as you were, you made at least three miscalculations: You thought

that, no matter how slowly, reason would eventually triumph. You thought that science, reason's favorite offspring, would be used for man's benefit. And you thought that when science was so used, whenever ignorance and superstition and disease were conquered, men would be happier than they had been before.

VOLTAIRE

When I was a boy and first learned about government and the state, I thought that laws were like repairs on a watch, or corrections in a drawing; they were ways of perfecting the imperfect in obedience to a static model. And I thought in my innocence that the need for laws and lawmakers would steadily diminish, and eventually disappear, once all the flaws had been eliminated, all the distortions corrected. It was only much later that the essentially dynamic, forever unfinished nature of social life dawned on me. Then I came to see the perpetual need for legislative action, the perpetual need for social criticism, in a word, the perpetual need for philosophes.

ERASMUS

However you twist it, the predictions you made, or your followers made on the basis of your writings, have on the whole not been confirmed. The decline of superstition has resulted not in the diminution of unreason but in its shift to other fields; unreason has found new forms of expression—nationalism, imperialism, fascism, bolshe-

vism. Unreason has taken its revenge on you men of reason by becoming cannier and more bloodthirsty than ever before.

VOLTAIRE

I wish humanity well enough to wish that I could crush you with my reply. But sadly I must concede that you are right. Reason has moved more slowly, and conquered fewer areas, than we thought it would. But we never equated knowledge with virtue.

ERASMUS

You didn't? I thought that this was precisely what you did.

VOLTAIRE

Not at all. Diderot said—

ERASMUS

Very well. Spare me your quotations.

VOLTAIRE

We thought that knowledge and virtue were friends, not synonyms. We knew enough about science to know that learning can be abused by an exclusive caste to its own advantage—even Condorcet knew that. We knew enough about statesmanship to know that knowledge can be pressed into the service of the most evil designs—Montesquieu, Bentham, and, I feel compelled to add, Gibbon analyzed the stratagems of rulers at length and with great subtlety.

ERASMUS

Perhaps. But you did not really expect that the natural sciences, of which you were so enamoured, would be systematically employed for the sake of private profit or general destruction; or that the social sciences, in which you placed such extravagant hopes, would be systematically employed to induce men to want what they did not need, choose what would do them harm, reward their exploiters and cheer their oppressors.

VOLTAIRE

True, we did not really expect that—though I must insist that it was only to the extent that the natural and the social sciences departed from our critical principles that they became instruments of evil. But I must admit that we underestimated man's obtuseness, his perversity, his positive love of disaster.

ERASMUS

And you were just as wrong about man's happiness. Look about you. At your prompting, modern reformers liberated merchants and manufacturers from those hateful medieval constraints—as you called them—and to what end? Freedom only gave them unprecedented opportunities to enrich themselves, to exploit their workingmen, to corrupt the officials appointed to watch over them, and to drown the world in shoddy goods. High-minded public servants—your followers!—built houses for the poor, only to see the new dwellings degraded into hovels

as horrible as the old tenements. Humanitarians freed the slaves, and freedmen riot in the streets. Liberal empires gave independence to countries they had grown ashamed of oppressing—it was your philosophy, you know, that made them ashamed—and the new nations have used their independence to demonstrate a frightful ferocity and a total incapacity to govern themselves. Well-meaning educators constructed schools, printed books, forced education on everyone, disseminated culture and information in attractive and unprecedented ways, all in quantities wholly unimaginable in my, and even in your, day—all in vain. The plebs continue to prefer trash to quality, vulgarity to refinement, the fashionable to the enduring, and they have committed crimes by the books their teachers had taught them to read. Statesmen learned—you taught them!—to be humane to criminals and lenient with children. What happened? Criminals have remained criminals, and children have become delinquents; ideas like responsibility, hard work, and self-respect have suffered ridicule, and almost disappeared from the world. Look at the cities: all the ingenuity employed to make cities—the glory, the repository, of civilization!—more delightful has made them into uninhabitable rabbit warrens, where the water is disgusting, the air lethal, and the street unsafe. It is not that progress has exacted its cost: progress has made life intolerable. Scientists have improved men's diet, physicians have lengthened men's lives, inventors have lightened men's labor, men of good will have ensured men more leisure than they have ever had in history.

But while the quantity of life on earth has grown —when it is not being decimated by modern mass war—the quality of life has deteriorated. And could you, in your most oppressive nightmares, have dreamt of the Nazis, who applied all the resources of scientific cunning to degrade, torment, and finally to murder men—and women and children as well —by the millions, in the most revolting ways, compelling hapless men to select their friends for slaughter, and mothers to point out their children to executioners, depopulating villages and cities through large-scale reprisals for single acts of rebellion, through bestial medical experiments, diabolical tortures, until many of their victims would die of sheer heartbreak standing in their own excrement?

VOLTAIRE

No: I could not have dreamt it. The Marquis de Sade, that madman who mouthed our slogans and defiled our ideas, could have dreamt it, but not I. You overwhelm me. Much of what you say is untrue: you do not really suppose, do you, that your cities were any safer, any healthier, any more civilized than the cities of the twentieth century? Much of what you say is unjust: the unwashed are not incapable of instruction—I saw that even in my own day; and we must be patient with the freedmen—we gave them much to riot about. But you are right about modern barbarism, barbarism all the more appalling because it followed upon such high hopes—hopes that we were not alone to harbor! Still, not even the Nazis could kill the

spirit of decency, indignation, and courage. There were Jews who rebelled, Dutchmen and Danes who helped them; there were even a few decent Germans.

ERASMUS

To say, as you just have, that there is some good in man, and to find very little more to say, is to join the company of Christians. Four and a half centuries ago, I chronicled man's folly; imagine how much more material I would have now. Man is not the rational but the insatiable animal: satisfy one of his desires, and ten dissatisfactions arise. Deprive him of what he wants, and he will be miserable; give him what he wants, and he will be miserable still. Seneca's Medea is not a caricature of humanity but its fitting representative: man, as she said, sees the better and chooses the worse.

VOLTAIRE

And do you suppose that we did not know, or did not wholly accept, Seneca's famous line? Diderot said—

ERASMUS

Yes, yes. You honored the saying in words, but you did not really understand it. If you had understood it, you would not have raised men's hopes with your philosophy: you have only plunged him into despair. You aroused expectations that could not be fulfilled—the very height of irresponsibility.

VOLTAIRE

While you Christians prevent men from exercising their powers—the very height of wickedness.

No: it would have been cheaper and more charitable to do nothing; it would have been better by far to keep alive in men's hearts the consolations of true faith. Gibbon was right to complain of those who deprived men of religion, wrong only to include me among the destroyers of celestial hope—I only tried to clear away the weeds, that true religion might blossom. Men are by all accounts as confused, as irrational, as bored—in a word, as unhappy—as ever. Consider that strange modern phenomenon: the revolt of the prosperous.

VOLTAIRE

There is still plenty of poverty to go around.

ERASMUS

True, but the revolt of the wretched is not surprising, nor is it a difficulty for your philosophy. The misery of those who have enough *is* a difficulty. You thought that once you give men enough, they will be happy. You were wrong. And that proves the ineradicable contradictions in man, conflicts that no amount of new inventions, better food, or critical thinking can resolve, the unappeasable hunger that is the consequence of original sin.

VOLTAIRE

The revolt of the prosperous, as you call it, is neither a mystery to me nor a difficulty for the philosophy of the Enlightenment. They do not have enough—by definition.

Because God has left their lives, and, with Him,
purpose. That is why man needs religion: to keep
sane, not merely in a terrifying universe, but
amidst a mad species—his own. Lucian said that
you miscalculated. That would be forgivable; we
all miscalculate. You did far worse: the philosophy
of the Enlightenment was a false philosophy from
beginning to end, a tower of self-deception built on
the swamp of rationalism. No wonder it has come
crashing down about our ears, and yours.

VOLTAIRE

The twentieth century has its miseries. Every cen-
tury has its miseries. We never doubted that it
was so, and we never promised that the day would
come when it would not be so. Yes: we underesti-
mated man's capacity for diabolical ingenuity, but
for the rest, our philosophy made room for fallibil-
ity, for stupidity and viciousness. We all said so
—I said so over and over again. Is it my fault
that my laments were not taken seriously just be-
cause I was witty about them? My wit, if I may say
so, was a sign not of callousness but of courage. We
were far from insensitive to man's need for con-
solation and the difficulties of enforcing social
discipline. That, in fact, is why we took so much
interest in social religion, that catalogue of noble
lies which most of us thought essential for the
illiterate—most of us, for we argued about this
matter as we argued about practically everything.
One thing we agreed on: we were too self-reliant,
too grown up, to need lies for ourselves. Yes: there

were times when we felt exceedingly gloomy and would say the kind of thing you just said. But, as reasonable men, we grew ashamed of our self-pity and went back to work. You know, when George Bernard Shaw wanted to give expression to views like yours, he put them into the mouth of the devil, for they are seductive and pernicious. To find nothing but evil in man's unaided efforts, and to see nothing but prospects for further gloom unless man sells himself into slavery or prays himself into a second childhood, is to invite passivity and make future disasters inevitable. We erred in our predictions, but if erroneous predictions damn a philosophy, every philosophy and theology alike would be damned—though all would not be damned alike. True: some of the preachers' predictions have been fulfilled: there have been war and pestilence and misery. But their prophecies were self-fulfilling prophecies. If we predicted that men would be happy yet they are not happy, I am sorry about it, for their sake, but I cannot accept responsibility for it—it is not our fault. Preachers predicted that men would be unhappy, and they saw to it that they would be right. For misery has come not from our philosophy but from that of our adversaries. We fought with all our strength, all our lives, the cruelty and irrationality that we saw around us. At most you can accuse us of ineffectuality, but of nothing more.

ERASMUS

You are making too much of what I said. No one here is accusing you of the crimes of the twentieth century.

There are those who do. There are those who accuse us of fathering modern totalitarianism. I told you: we have been called fanatics, and the fathers of fanatics. It is not true! When the Nazis occupied Paris, they melted down my statue. I suppose they needed the metal to make guns, but I like to think that they could not bear the spirit of the Enlightenment.

ERASMUS

Confess it! These attacks are actually very convenient for you. By dwelling on unreasonable criticisms you divert attention from reasonable criticisms. You cannot evade us so easily. Your failure to foresee the course of events is not a casual failure; it reflects back on your philosophy as a whole, and suggests a profound lack of vision.

LUCIAN

Precisely. The point is not that your hopes have by and large not been realized. The point is that your hopes were in themselves unreasonable. And when I put it this way, I think, we have reached the core of the problem of optimism: reason, and its powers, played a far too prominent role in your philosophy.

VOLTAIRE

Contrary to its reputation, the Enlightenment was not an Age of Reason but a Revolt against Rationalism.

ERASMUS

A slogan, no more. You dare not deny that reason was your final arbiter, your greatest hope, your highest ideal.

VOLTAIRE

Why should I deny what I am proud to affirm? Our revolt against rationalism was not a revolt against reason. It was a revolt against the Scholastics' love of words and the metaphysicians' love of vast constructions. We attacked reason in the name of reason. The kind of reason we cherished was in touch with reality, it lived on things rather than words, sought accuracy rather than neatness. It was scientific method: searching, self-critical, modest, effective. And it was not hostile to the passions—on the contrary, we philosophes recognized the power and admired the work of the passions—

LUCIAN

Within reason—

VOLTAIRE

If you like: within reason. When Hume said that reason is, and ought to be, the slave of the passions, he put it a little strongly, but he was making our case. Diderot said—

LUCIAN

Yes. For all of that, you misjudged the tenacity of unreason—its pervasiveness, its persistence, its

imperviousness to rational control. The course of modern history should prove that empirically.

ERASMUS

And the findings of modern psychology have proved it scientifically.

VOLTAIRE

Are you speaking of Sigmund Freud?

ERASMUS

I am. The man is positively Christian in his pessimism. He has shown conclusively that man is inherently a sinner filled with murderous thoughts, a fallen creature whose most profound ideas and feelings are inaccessible to him, and hence incorrigible by good intentions or rational will. The whole corpus of his work is one large Praise of Folly. And it exposes your philosophy to be naïve, shallow, wholly out of date.

VOLTAIRE

That's larceny! You are stealing our man!

LUCIAN

You did anticipate him, of course: the study of dreams, the Oedipus complex, the sexual origins of moral notions . . .

VOLTAIRE

True. But as I said before: I do not like to rest my case on anticipations. Freud belongs to the family of philosophes not because we anticipated him but

because, whatever he discovered, he discovered with our methods, within the range of our intellectual style. His view of man, like ours, was secular; his explanations of man's aggressiveness drew not on some fairy tale about man's disobedience to God but on purely natural causes; his system was not metaphysics but science.

ERASMUS

But is not Freud's notion of aggression merely a secularized version of original sin?

VOLTAIRE

It is not, it is the fruit of clinical observation. He studied dreams, he was not a dreamer.

LUCIAN

Perhaps. But why, of all twentieth-century figures, concentrate on Freud?

VOLTAIRE

You brought him up, not I. Though I am pleased that you did. For Freud, whom you take to be the nemesis of the philosophes, was, in fact, our most distinguished representative in the twentieth century. To grasp this is to grasp not merely the meaning of Freud but the meaning of the Enlightenment. Those who invoke Freud without reading him forget that his *attitude* toward reason coincides with ours, even if his *estimation* of it rather differed from ours. And they forget that he concentrated on unreason not to celebrate but to defeat it.

LUCIAN

He dredged up many awful mysteries: the uncon-
scious, the sexual wishes of children.

VOLTAIRE

Not to wallow in them, but to understand them. He
believed, as we did, and, I'll admit, with sounder
evidence, that reason is weak and divided, but he
wished to strengthen and to unify it. He believed,
as we did (if I may cite the New Testament), that
we should know the truth, and that the truth would
make us free. "Science is no illusion," he said.
"But it would be an illusion to suppose that we
could get anywhere else what it cannot give us."
If this is not Enlightenment thinking, I do not
know what is.

LUCIAN

Yet he was convinced that love and aggression
would always tear man apart and make him, as
long as he lives, at best uneasy, at worst miserable.

VOLTAIRE

He denied that complete happiness is possible. So
did we. Neither he nor we ever asked for immobile
serenity. We asked for the happiness of activity,
of enjoyment amidst the risks of life. Freud said:
Where id was, there shall ego be. We put it differ-
ently. We said: Men can learn to reconcile freedom
and discipline and to reduce their sufferings. Do
you know, Lucian, when you were telling us your
fable, I kept thinking of Freud? He would have

liked it, for the same reason that I liked it: he knew, as we knew, that civilization is a burden; that it demands self-denial for the sake of self-fulfillment, the capacity to postpone gratifications and to moderate one's desires. But he also knew, as we know, that it is a glorious burden, a destiny that man must accept if he wants to be a man. He wanted to reduce the burdens of civilization, to identify and eliminate those that had been imposed by false moral and religious notions, but he never for a moment believed that all burdens were unnecessary. Yet while we thought that total, infantile contentment was both unattainable and undesirable, we thought that we must never cease to reduce suffering. We believed that to feed someone who is hungry is to make him happy, if only for an hour; to free someone from a superstition is to lift an oppression from his shoulders, if only one among many; to exercise one's mind and gratify one's body freely is better than to be chained to timidity and asceticism. To say that all these things do not make men ultimately happy is not to say that their pursuit is not worthwhile, or that their absence would not make men even less happy. To turn away from reform because it does not make men perfect is like hating your parents because you have discovered that they are not omnipotent. These are simple truths, incomprehensible only to jaded voluptuaries, disillusioned radicals, or gloomy fanatics. No, no: if the Enlightenment had never existed, the world, miserable as it is, would be far more miserable still.

ERASMUS

This is precisely what I find it impossible to believe.
You keep telling us that you philosophes were
realists, yet we have compelled you to admit that
history has proved you wrong over and over again.
No: you were not realists at all: you were Utopians.

VOLTAIRE

I know how much it irritates you when I convert a
criticism into a commendation, but at the risk of
annoying you once again, let me say that I accept
the charge of Utopianism with pleasure, though
I interpret the term in my own way. I need not
tell you—were you not, after all, Thomas More's
friend?—that there are many reasons for Utopian-
ism. Some Utopias, to be sure, read like fancies and
wishes in the form of a story; they are like the
little fairy tales a child tells himself to still the
terror of the dark. But there are other kinds of
Utopias, far more earthbound than these, the off-
spring not of night but of day. These Utopias
describe conditions that, though they are not yet
real, may become real—they show the potential as
actuality. They are social criticisms or social pro-
grams pleasingly disguised as Oriental tales or
adventures in imaginary kingdoms. Our Utopian-
ism was of this second kind—shall I call it realistic
Utopianism? No reformer can do without this kind
of Utopian thinking; to do without it is to be like
Pangloss, to hold that what is must be and need
not—no, cannot—be improved. That kind of com-
placency is simply another form of despair.

I am reminded of an old story—not freshly invented like Lucian's fable, but a tale told many times. Once there was a prosperous farmer who had three sons. He lived long and worked hard, and when time came for him to die, he gathered his sons around him and told them that he was leaving them all his land and all his savings—a large chest filled with gold coins buried on his property. Then he died, without telling them where the chest lay buried. The three sons began to search for it. They turned over the ground with great care, as they had always done, but more diligently, more thoroughly, than they had ever done before. They searched and searched, dug and dug, and they never found the legacy their father had promised them. But, as you have guessed by now, there was no chest; there were no gold coins; there was only the fertile land. And in the course of digging for this imaginary treasure, the sons gathered up a very real treasure, for with their incessant labor they magnificently cultivated the soil and produced richer crops than ever. Thus the unattainable may serve as a guide and a goad to the attainable. We must cultivate our garden, even if it is only the garden of hope.

IV ON IMAGINATION

LUCIAN

We must cultivate our garden—agreed! But I always thought that your garden was the garden of fact, and that the Enlightenment had no use for the imagination.

VOLTAIRE

We did not despise the imagination. We only distrusted fancy, with its childish, drunken, deranged nightmares and its terrifying, destructive offspring: artistic incoherence, philosophical confusion, religious persecution, political fanaticism. We never begrudged the secret passions their share in the making of man's creations. The virtue of our view of the imagination was that it was solidly grounded in the discoveries of our favorite philosophers—of Locke and of Condillac. It was a simple view, perhaps, but wholly adequate: the sensations

supply the mind with its raw materials, and the mind then fashions these materials into myriad shapes. I say myriad shapes: the sensations men take in are so numerous and so varied that men can populate their world with the most astonishing, most bizarre inventions by the process of combination alone. They could make unicorns and centaurs, construct machines and governments, invent gods and other fairy tales. I assure you: our view of the imagination was large enough, generous enough, flexible enough, to account for the work of artists and scientists alike.

ERASMUS

The man who believes that will believe anything. Could your view of the imagination account for Dürer, Michelangelo, Raphael, Copernicus? Those geniuses needed better air to breathe than you would have given them!

VOLTAIRE

True: we did not make a cult of the genius—we did not like to make a cult of anything—but we honored him, even as he disregarded our most cherished precepts.

ERASMUS

Your kind of genius was no genius: he was a mere man like all others, towering over them only because they were so short. Match those giants of my day—my contemporaries, all of them!—against the most popular artists and writers of your day. Who were they? Boucher, an open panderer to the

lowest sensuality—*there* was a passion for which
you had some use! Greuze, who was worse than
Boucher, for he concealed his pandering behind
shallow moralizing, to make it more titillating. Rich-
ardson, a storyteller for chambermaids—and for
sentimental Stoics like your friend Diderot.
Houdon, a pygmy compared to the sculptors of my
time—

VOLTAIRE

He did very satisfactory busts of me.

ERASMUS

Poor man, he had nothing more elevated to occupy
him. Is it accidental that yours has been called an
age of prose—that is to say, of *mere* prose? Is it an
accident that you excelled, if you excelled in any-
thing, in the portrait and the essay? When I said
that you had no use for the imagination, I put it far
too generously: you were its deadly enemies. I am
inclined to set a gravestone and carve on it: "Here
lies the Imagination. Born in the enchanted mists
of remote antiquity, died in the cold air of the
eighteenth century, of philosophy and science, fol-
lowing prolonged malnutrition and exposure."

VOLTAIRE

Only to rise again after three days, I suppose—or,
rather, decades—in the Romantic Age?

ERASMUS

Yes. It rose again—splendidly. The Romantic view
of art, its celebration of genius, of the imagination,

of self-expression, stands like a barrier between your aesthetics and modern aesthetics. Your theory of the imagination was mechanical, additive; the Romantics endowed the imagination with creative powers. They did what you claim you did: liberate the impulses of invention, dig deep to the very springs of productivity. And not in theory alone: read your most accomplished poems—even by Pope —and then read a poem by Keats or Shelley; it is like moving from an oppressive room into open nature.

VOLTAIRE

The Enlightenment was no stranger to the creative imagination. Leibniz—

ERASMUS

I never cease to admire the ease with which you convert your victims into your witnesses. Did you not cruelly mock Leibniz—or, rather, first make a mockery of his philosophy, to turn it into a target? But more important: Leibniz' theory of the plastic imagination was taken up by only a few obscure German psychologists whom you either did not read or did not follow. You have admitted it yourself: you did not think that the mind is creative at all. You thought that it works as a mason works with bricks he has not made—a passive, menial, thoroughly mediocre estimate of mental activity!

VOLTAIRE

If you will not grant me Leibniz' theory, I can do without it. In fact, most of us did without it, and

did very well. But what I said about our theory of human nature I can also say about our theory of the imagination: as the first was adequate to all the diversity historians could discover in the past, the second was adequate to the most strenuous demands that artists or scientists could make upon it. You say we degraded the imagination to the lowly work of the mason. Why not say we exalted it to the sphere of Plato's God, the divine craftsman, who made the world with materials he found ready to hand? You have said that the eighteenth century was less than first-rate in the arts and sciences, and you said it with an air of discovery. You could have read that charge first in our writings, especially in mine. That ours should have been a silver age, after the golden age of Louis XIV, oppressed me all my life. I told you—didn't I?—we were scarcely optimists.

LUCIAN

Silver is not a despicable metal.

VOLTAIRE

No, and ours was by no means a despicable century; in painting and architecture quite as much as in physics and mathematics, it was a delightful and productive time. We fell short, yes—after all, how many Corneilles, how many Newtons, can a civilization bring forth? But if we fell short, it was not our psychological theories that were at fault. And in any event, our psychological theories were not faulty.

LUCIAN

Your psychological theories have been discredited and superseded. You cannot evade it, Voltaire: your view of the imagination was thin and pallid, and, besides, you wanted it that way: it was a preference disguised as a scientific law, and it did much to inhibit the realization of man's imaginative potentialities.

VOLTAIRE

We thought that this was one of its greatest excellences.

ERASMUS

In the sciences, of course. But in the arts its influence was nothing less than disastrous.

VOLTAIRE

I am ready to rest my case on the arts. What you call inhibition and see as a defect, we called the will to form and saw as a virtue—saw, in fact, as the cardinal virtue of our aesthetics. And now I see it as our distinctive legacy to the art of the twentieth century. What we sought, and what I think we found, is precisely what modern art needs: the proper balance between talent and learning, intuition and craftsmanship, the freedom of spontaneity and the discipline of form.

ERASMUS

To pile one false claim upon another is only to make your shortcomings more visible. Actually, you were all form and no freedom: you neglected intuition

for craftsmanship, and despised spontaneity in the name of discipline. What is true of the imagination is true of the rest of your aesthetic thought. You were loyal, timid neoclassicists; you carried about the legislation of neoclassicism, its catalogue of prohibitions, like so many chains. The antique rules that we handled with supreme self-confidence weighed on you as a burden you dared not shake off. Diderot—that great radical!—defended the rules of neoclassical drama as sensible. You—another great radical!—denounced Shakespeare as a barbarian for mixing low comedy with high tragedy. In painting, all of you remained faithful to the traditional hierarchies—even Hogarth felt bound to try his hand at history painting.

LUCIAN

It is true, Voltaire: Horace would have found few surprises in your writings on aesthetics.

VOLTAIRE

Yes and no. We tried to rescue from the ancients what was valuable to our time. We were classicists more than neoclassicists. You must distinguish our artistic ideas from the academic doctrines of the eighteenth century; we deplored the dictatorship of the academies—

ERASMUS

Yes, until you were elected to them.

VOLTAIRE

It was gratifying to be called immortal, especially since we thought we deserved it. But while election

to an academy would disarm our malice, it never weakened our critical energies; we continued to despise the uninspired poems, the lifeless palaces, the tiresome historical paintings which were the mark of the academic mind. The most inventive thing the academicians did was tombs.

LUCIAN

Except in England.

VOLTAIRE

Of course: except in England; there the academies were assemblies of free men. On the Continent, they were gatherings of slaves.

ERASMUS

But you joined them just the same, in France, in Prussia, in fact everywhere there were academies that would have you. Was it vanity alone, or some deep affinity?

VOLTAIRE

It was neither deep affinity nor vanity alone. We joined the academies to raise our status, improve our income, appease our censors, and increase our influence; we voted our friends in and continued to do our best work outside. And that work was far more radical than you seem to think, far more radical than many people seem to think. Remember Diderot's experimental dialogues and formless novels and bourgeois dramas—they were mortally tiresome, those dramas! But they were revolutionary just the same. Remember our admiration for

Chardin, with his genre scenes and still lifes, which made him the lowliest of painters by neoclassical canons. Remember me: I, too, was a reformer in the arts. Indolent scholars have thought they can label me as a neoclassicist and then have done with my writings. But, in fact, my tragedies were filled with innovations which surprised my audiences quite as much as they delighted them, and which they all recognized as innovations: do you think it was a small thing to clear the stage of spectators? to introduce cannon shots into the drama? to present dramatic action without love? to produce tragedies not of passion but of ideas? And there is more: remember our decisive assault on all the time-honored, timeworn attempts to find the objective laws of beauty, those laws based on numbers or proportions that would tell men what was beautiful, what was ugly. Ancient Egyptian priests and Greek philosophers, medieval theologians and Renaissance painters sought desperately what we proved, once and for all, could not be found and was not worth finding. We discovered the meaning of taste and made it respectable.

LUCIAN

If you made it respectable, the twentieth century has debased it. Now it simply means a casual, unstudied, often quite irresponsible choice of one thing over another.

VOLTAIRE

We were more careful in our language: to us, taste was subjective but not capricious, an educated

faculty for the perception of artistic excellence. But then, if we were conservatives in our language, we were conservatives in our language alone. Do not be misled by it: like many revolutionaries we used old words after we had discarded the old ideas. Take the trouble to read the pronouncements of Diderot on the arts—and he pronounced on them all too freely, for forty years!—and read them as I read them: chronologically. They add up to a drama more dramatic than any play he ever wrote: the slow, even reluctant, but in the end decisive development of a revolutionary—of a modern in spite of himself. Our aesthetic thought amounted to nothing less than a Copernican Revolution. If there were any chains on us, we wore them lightly and toyed with them at our pleasure. We were free men; it was as free men that we obeyed laws. That is why the twentieth century needs us, and can use us.

LUCIAN

I wonder. Nothing is more unstable than modern taste—the career of your own writings is sad proof of that. In your day you were the most famous dramatist in Europe; today a few unfortunate schoolchildren must be flogged into memorizing your greatest tragedies.

VOLTAIRE

I am afraid you are right. The history of taste, I suppose, is the history of rising and declining reputations, a record of views discredited and minds changed. The twentieth century looks at eighteenth-century art and finds it tepid; we look at twentieth-

century art and find it chaotic. I am enough of an empiricist to believe that probably we are both wrong. One man's chaos is another man's order. The most rigorous organization, closely observed, betrays strains and disharmonies; formlessness, closely observed, reveals form. The traditional has its surprises; unconventionality its own conventions. New and unfamiliar forms may appear to be formless: what we perceive as form is a matter of habit, like almost everything else. A composer produces a new piece of music, and his listeners reject it as sheer cacophony; the next generation, schooled to receive it, finds it melodious and orderly; and the generation after that yawns at it —that is to say, calls it a classic. Seventy years ago, critics railed at Impressionism; today it is old-fashioned and tame enough to be the favorite style of the artistic illiterate. Fifty years ago, Dadaists were denounced as madmen and dangerous anarchists; today they appear innocuous, mildly amusing.

LUCIAN

All these are commonplaces in the history of the arts. But what, in this world of shifting aesthetic allegiances, capricious revivals, and an articulateness that conceals intellectual poverty, do you, as a philosophe, have to offer the twentieth century? Certainly not the models of specific novels, or paintings, or dramas.

VOLTAIRE

Not that, but a general vision: respect for the old and pressure toward the new.

LUCIAN

We know that you were well schooled in the old. How receptive were you, really, to the new?

VOLTAIRE

We welcomed the new only if we found it good. Open-mindedness is not the same thing as empty-headedness. To accept everything that is new simply because it is new is to abdicate one's responsibility as a critic; it is to dismiss the whole past as worthless, and that is barbarism in the name of radicalism. It resembles the perpetual desire to be young rather than to act one's age—a sure invitation to cultural disaster. The danger to modern art is not its imaginative freedom itself, but the temptations to which this freedom gives rise. What modern lovers of the arts need, therefore, is the intelligence to discriminate between freedom and fashion, and the independence to reject mere fads, popular though they may be. The tyranny of the old, which was the tyranny of our century, was pernicious, but it was less pernicious than the tyranny of the new, which is the tyranny of the twentieth century. That is why I say modern art needs us.

LUCIAN

Did you really suffer from the tyranny of the old? Even in earlier, more constricted times, artists could find room for maneuver and range for individuality, as long as they gave respectable reasons for what they were doing, and had a liberal

and sensitive patron to protect and pamper them. And does modern art really lie helpless before the tyranny of the new?

ERASMUS

And even if it needs you—which I doubt—can it use you? Can modern artists hear what you say? Or, if they could hear you, would they understand you? You call your aesthetics a Copernican Revolution, but just as Copernicus did not directly produce modern science, so your revolution in aesthetics had to be followed by another before we could speak of truly modern art. And that second revolution, I insist, was made by the Romantics: the Romantics are the fathers of modern art and literature, not you.

VOLTAIRE

If they were its fathers, we were its grandfathers.

ERASMUS

Next you are going to tell us that what is sound about Romantic thought is a legacy from the Enlightenment, and that what is not a legacy from you is not sound.

VOLTAIRE

As a matter of fact, I *was* going to say that. How did you know?

LUCIAN

Whatever you may say about the Romantics, what the Romantics said about you was very different,

and remains very instructive. You philosophes, they said, robbed the rose of its perfume, the bird of its song, the rainbow of its magic. You philosophes, they said, deposed quality—the stuff from which great music, great painting, great poetry are made —and enthroned quantity in its stead; you inaugurated the reign of numbers. But, unlike the sacred numbers of Pythagoras or Plato, yours had no charm, and no charms. You philosophes, they said, tore the emotions from men's hearts and locked them in the laboratory. Where you should have loved, you analyzed; where you should have admired, you measured and counted; where you should have stood in awed silence, you filled out charts. How did Wordsworth say it? "We murder to dissect." He was speaking about you: in those four words, you stand condemned. Beauty left you cold, and so you left it cold—that is, dead— while you chanted your formulas over it.

VOLTAIRE

A touching collection of aphorisms, but not *the* Romantic position. Call it, rather, the ravings of a few drunken Romantics.

LUCIAN

A few drunken Romantics?

VOLTAIRE

Have you ever heard of that famous dinner that Benjamin Haydon gave—in December 1817, I think? He was a mediocre painter, an egotist, and an eccentric, but he seems to have known everybody.

Keats was at that dinner, and Charles Lamb, and Wordsworth. The high point of what appears to have been an orgy of talk and wine was a vehement attack on modern science, culminating in a rude toast of "Confusion to mathematics" or—the accounts vary—"Confusion to the memory of Newton." However the toast ran, it amounts to the familiar charge that science is the mortal enemy of poetry.

LUCIAN

I shall grant you "drunken." But "a few"? Haydon, Keats, Lamb, Wordsworth—it seems a most representative gathering of Romantic spirits. Besides, Coleridge, or Chateaubriand, or the brothers Schlegel, or Goethe—who was half a Romantic— would have joined in that toast had they been there.

VOLTAIRE

Shelley, who was a whole Romantic, would have refused. And Wordsworth, who was a thoughtful man, hesitated before he joined in. Of course, I can hardly blame either of you for pitting the Romantics against us. You are simply repeating the nonsense you find in all the books: you know—the Romantics are the antithesis of the Enlightenment; they, emotional, exuberant, poetic, religious, and reactionary; we, rational, classical, scientific, impious, and revolutionary. Actually, the more I read the Romantics, the more I find myself in them— certainly in the English Romantics, less so in the French, in the Germans not at all.

LUCIAN

Unless you count that unclassifiable figure, Goethe, or your wayward son, Heine, among the Romantics.

VOLTAIRE

Yes, but the English Romantics remain my favorite reading. As I was a disciple of Englishmen, Englishmen came to be my disciples. Byron—need I remind you?—was a religious unbeliever, political radical, a wit after my own heart. Shelley, another skeptic and radical, was positively in love with science, and thought poetry not its enemy but its sister. And Wordsworth—well: you quoted his famous assault on the intellect. Why not quote his defense of "the habit of analysing, decomposing, and anatomizing"? Accurate, critical knowledge enhances our capacity to appreciate beauty—that is good Enlightenment doctrine. There can be no doubt: what is usually called Romanticism is really a most incongruous and highly volatile mixture of ideas and attitudes—many of them taken quite directly from the Enlightenment.

LUCIAN

You as a historian should know that the longer you study a historical period, the harder you stare at it, the more differentiated it becomes. What appears at first as a solid outline, with simple shape and single color, emerges as a complex network of lines and juxtaposition of patches. In the same way, a period comes to show greater and greater resemblance to others. But to perceive the subtleties

within a period, and its affinities for other periods, should not induce us to neglect the qualities that distinguish one period from another.

VOLTAIRE

Why insist on it? All this is obvious.

LUCIAN

It seems not to be obvious to you. You were in the process of converting Romanticism into a—what shall I say?—disappointing child of the Enlightenment, full of talent, displaying occasional brilliant flashes reminiscent of its father, but led astray by bad company.

VOLTAIRE

Yes: led astray by priests, knights, fatal ladies, peasants, and children. The Romantics wrote many fine poems. They wrote some fine plays, some fine novels, some fine music. But they also talked much fine nonsense about the arts. If nonsense is modern, then let them engross that name. Some of their more fluent and most influential writers—I must insist on that word "some," for the Romantics disagreed on questions of art far more vehemently than we ever did—some of their more fluent and most influential writers, I say, only undid what we had so laboriously built and so thoroughly proved: they rehabilitated the Middle Ages as a glorious, enchanting time of flowering knighthood, magnificent cathedrals, and touching faith after we had exposed the age as shabby, brutal, and fanatical. They made free with our doctrine of the autonomy

of art to advance untenable, in fact frightening, claims—you know: the poet as legislator.

LUCIAN

Right or wrong, what is frightening about that?

VOLTAIRE

They coupled it with an obscurantist view of knowledge. They claimed for the poet and the artist in general privileged access to truths that scientists and philosophers will never reach—and why? Because poets and artists are the guardians of strange mysteries and have retained the wise innocence of the child.

LUCIAN

These charges sound like your sarcasms against Rousseau. You have suggested that the Romantics were the heirs of the eighteenth century. You would have done better to say that they were the heirs of Rousseau, the savage philosopher.

VOLTAIRE

Yes—I mean no. Rousseau was perverse, ungrateful, often treacherous and always sentimental. He was impossible to live with. It is tempting to say that the Romantics learned sentimentality from him and reasonableness from us. But it would not be just to him. We were not always just to him in our time—he *was* impossible to live with!—but I have come to see that he, like the rest of us, cherished reason and discipline and critical thinking. He said in *Émile* that Plato's *Republic* was not a

treatise on politics, but the greatest treatise on education ever written. I am inclined to say now that *Émile* was really a great Enlightenment treatise on the cultivation of reason.

LUCIAN

If you can both claim Rousseau and turn him into a rationalist, you can certainly claim that your commitment to form did not compromise your love of freedom.

VOLTAIRE

That was my intention. Any philosophy of art needs both. Rules may distort talents, stifle inventiveness, reward the pliant courtier, and penalize the genius. But their absence makes everything possible, deprives everything of distinctive value, prevents the recognition of excellence or of mediocrity.

LUCIAN

Yet times of confusion may be times of gestation; formlessness, aimlessness, may be the birth pangs of a splendid new age. And you will only know afterward.

VOLTAIRE

Did I not plead—in the name of the Enlightenment—for open-mindedness? No aesthetic judgment is final—that judgment alone is final. But to say that all judgments are provisional is not to say that they all have equal merit, or that they are all useless.

ERASMUS

And so your ideal critic—an empiricist and an intellectual—turns out, by a peculiar coincidence, to be yourself.

VOLTAIRE

Say, rather: turns out to be a philosophe—not just me, but Diderot as well, and Lessing. In fact, the philosophe who defined the critic most succinctly and most successfully was David Hume. The critic, he says, is the intelligent arbiter of aesthetic disputes. For this much is obvious: men strongly disagree over matters of taste; in fact, their disagreements are even deeper than might at first appear, for while they may all agree that some quality—say, decorum—is praiseworthy in the arts, they are likely to disagree over just what that quality is. Finding such disharmonies uncomfortable, they seek to settle them by discovering some standard of taste that will permit them to make decisions and reach agreement. This is where the critic comes in: that standard of taste, Hume insists, can be found only in experience, and through experience, and it is only the experienced judge who can preside over the resolution of differences in the arts.

LUCIAN

How can we be sure we have such a man before us?

VOLTAIRE

The sound critic, Hume says, is a man who first of all enjoys good health and spirits—lacking either,

his judgment is bound to be defective. Next, he must bring to his task a certain delicacy of imagination.

LUCIAN

But that is an inborn quality, not an acquired one.

VOLTAIRE

It is cultivated in exposure, sharpened through practice. If Hume had lived to hear all that Romantic nonsense about the superiority of childlike innocence over mature reason, he would have been appalled. By practice, Hume meant serious, continuous, repeated attention to a work of art, and suitable comparisons with others. And finally—

LUCIAN

There is more?

VOLTAIRE

Yes. The good critic, with his sound sense and well-trained sensibility, must seek to clear his mind of prejudice.

LUCIAN

Surely an impossibility.

VOLTAIRE

But an ideal which the critic must attempt, if not to realize, at least to approach.

ERASMUS

A pathetic effort, all this, on the part of a skeptic frightened by his own boldness, a wrecker who tries to restore what he has destroyed. The critics in the

classical tradition—my tradition!—could make the decisions Hume so desperately seeks, because they had objective rules, standards of beauty, canons of appropriateness. You philosophes—all of you, not just Hume—wandered in a maze of contradictions. First you made beauty wholly subjective. Then you expressed horror at the specter you called up and bravely claimed that you had found other, better standards of aesthetic judgment.

VOLTAIRE

But don't you see? This is precisely what I meant by our Copernican Revolution and our permanent legacy. In the philosophy of art, as elsewhere, we preferred difficult truths to comfortable evasions. We discarded the certainties offered to us by myths and metaphysics not because they were easy but because they were false, though I suppose we sensed that they must be false because they were so easy. But we did not make our revolution lightly. We did not abandon the search for objective standards of beauty because we reveled in subjectivity—quite the contrary, subjectivity always made us uncomfortable—but because these standards were not to be found. But while subjectivity was our starting point, we trusted to cultivated intelligence to supply us with authentic objectivity.

LUCIAN

But hardly full agreement! Does Hume discover reasons why everyone must love Horace?

He was too much the historian, too much the empiricist, for that. He knew that some variations in taste must always persist—and does not observation prove him right? Men's individual characters, the opinion governing their time and country, and their age, keep some differences alive: Horace, he said, is the favorite of the man of forty; at twenty he will prefer Ovid, and at fifty, Tacitus.

ERASMUS

That is not reassuring.

VOLTAIRE

It is all that civilized men have a right to expect. The application of cultivated intelligence to artistic experience—here is the first meaning of my formula: freedom and form.

LUCIAN

Civilized men . . . cultivated intelligence: it all sounds like an aristocracy—or shall I say plutocracy?—of critics.

VOLTAIRE

There is no room for universal and equal suffrage in the arts. But the aristocracy of critics is large enough, and open enough, to include the artists themselves.

ERASMUS

The learned artist! For once you are expounding sensible doctrine. No wonder: it was a Renaissance ideal—we liked to see artists literate, with a good grasp of the classics; we liked to see them consorting with their patrons on a footing of intimacy, talking about art, listening to poetry together.

VOLTAIRE

It is an ideal we took over from you. Do you know that Diderot told Catherine of Russia that I was a good poet because I was a learned man?

ERASMUS

A Renaissance ideal, an Enlightenment ideal, but scarcely a modern ideal. If we can find a common theme in the bewildering mass of voices clamoring to have a monopoly on the truth of modern art, it is this: far from laying claim to learning, modern artists take pride in ignorance. When they have lost it, they cultivate it: primitivism in one form or another is the philosophy of modern art. Read their manifestoes, Voltaire, and you will say to them what you once said to Rousseau after he sent you his discourse on the origins of inequality: here is a whole library of books against the human race, making you want to go on all fours. Composers discard craftsmanship to produce music by accident. Painters forget their training to cover canvases with random drippings from the loaded brush. Sculptors haunt museums of natural history to study, and copy, rude carvings from some remote South Sea island. For many decades now, artists,

not satisfied with reproducing the primitive arti-
facts they can see at home, have traveled to exotic
parts of the world to find inspiration there. Some
even stayed, loving the dirt and sharing the diseases
of savages. And those who came back to write or
paint or compose at home treasured the styles and
the subject matter they had gone to find. And all
of this is not simply the search for decoration, or
a casual interest in novelty. Read their manifes-
toes! Those artists who did not go to Tahiti found
their savages at home; they praised, not the art
of tribesmen and cannibals, but the art of children
and actually of madmen. And why? Because they
were weary of Western civilization—weary of the
city, of books, of reason itself.

LUCIAN

Ah, the cult of simplicity, of innocence, of sincerity
—we had it all in my time, with our eclogues and
our pastorals! And it was an old story then. Primi-
tivism, it seems, is as old as civilization.

ERASMUS

I doubt whether these modern artists ever read any
of you. They do not like to read.

LUCIAN

They probably read the Romantics, who read us.

ERASMUS

The Romantics were effete decadents compared to
these true primitives: at their worst they looked
back to the Middle Ages—an age dark but hardly
uncivilized. The modern primitive is a Romantic

with experience—with a century of philistinism, machine culture, and aesthetic democracy behind him. Do you know what modern art has come to? The favorite cliché of the illiterate before a modern painting is that a child could have painted that. It is the one remark that all plebeians make about modern art, and the one joke that all modern artists make about themselves. It would have been inconceivable in any other age.

VOLTAIRE

It would have been inconceivable in ours. Sometimes I pity the moderns, drowned in their profusion of styles, babble of opinions, evanescence of fashions! And what has happened to the clarity, the cogency, the sheer literacy of artists' prose? Reynolds was one of the leading aestheticians of my time; Falconet was a vigorous stylist. Today it is a wise precaution not to consult a painter about painting or an architect about architecture. Enjoy his work, but avoid his explanations. Yet, for all their scarcity—because of it—the Enlightenment ideals of the learned critic and the learned artist have not lost their value. And there is still another way in which form controls freedom in the arts: through craftsmanship. And here I am not so pessimistic as you are. Picasso, Klee, Kandinsky . . . superbly equipped, highly self-conscious craftsmen all.

ERASMUS

But their artistic intentions run all the other way. Klee thought that children, madmen, and savages have privileged insights into the world that are reflected in their art.

VOLTAIRE

I meant what I said: one must not listen to their voices, but look at their work. They may say what they will, Picasso is not a barbarian, Klee not a child, Kandinsky not simply a mystic. They know as well as anyone that no amateur could do the kind of work they do. If these artists quoted reminiscences of child art, or primitive art, or madman's art in their work, that was their choice, a deliberate aim realizable only through technical mastery—in a word, through form. The child, the savage, the madman must paint the way he paints; the artist chooses to distort his faces on the canvas or his shapes in stone; what the others are compelled to do he does deliberately, freely.

ERASMUS

On a fateful afternoon in the year 1910, Wassily Kandinsky returned to his studio in Munich and was stunned: in the dim light he failed to recognize one of his own canvases. Yet it seemed meaningful to him, and beautiful. On that day abstract art was born, art that owes nothing to natural shapes or human artifacts and that quotes only the artist himself. Here was a revolution far greater than your boasted Copernican Revolution, and a revolution, moreover, that owes nothing to you or your philosophy.

VOLTAIRE

Perhaps I exaggerated a bit when I hinted before that the Enlightenment is responsible for everything that is good about the twentieth century.

Still I cannot help feeling that our view of art somehow opened the gates to modern art. We did not preach the doctrine of art for art's sake, but we taught that art has its own logic and should not be burdened with irrelevant responsibilities. Of course, we knew that the work of art is a social artifact and has a determinate place in a stylistic tradition. We knew that the artist lives in his world —at a certain time, in a certain place. He fights his private demons, belongs to a social class, works within an artistic tradition which he is eager to perpetuate, perfect, modify, or overthrow. A complete interpretation of a work of art should doubtless require knowledge of biography, of history, of psychology, of sociology. You can doubtless learn a great deal about Dutch seventeenth-century furniture by studying the paintings of Vermeer: such a study is certainly legitimate, even if it is trivial. One can never know too much. And one thing that is worth knowing about the twentieth century is that modern artists are disciplined artists. Even Klee thought that discipline, economy, self-awareness were crucial; even he repudiated as a legend the common view that his painting was childish.

ERASMUS

I thought you did not listen to artists. You reject their testimony when it is inconvenient but accept it when it suits your argument.

VOLTAIRE

When a professed primitive boasts of his primitiveness, that is hardly worthy of remark. When the

same artist acknowledges his professional aware-
ness, that deserves our attention.

LUCIAN

All of this brings us back to our starting point: the
imagination. Everything you have said reduces the
artist to a craftsman, an intelligent, well-educated
craftsman, to be sure, but a rational being who ap-
plies reason to his handiwork. With all this talk of
discipline and workmanship, what happens to ar-
tistic intuition and artistic inspiration? That is
why we needed the Romantics: to liberate what you
had imprisoned, to feed what you had starved.

VOLTAIRE

Why not enjoy the Romantics for their works—
which are enjoyable enough—and forget about their
theories? We did not forget freedom. Intuition
and inspiration are mysterious. They were mys-
terious to us, they remain mysterious to the twen-
tieth century: even Freud shied away from the
question of artistic productivity. Consult the note-
books of the poets and composers, and you will find
that what seems easy, inevitable, was actually the
result of laborious revision and diligent reshaping.
The artist himself may not always know this, but
it is true.

LUCIAN

But then where is your freedom?

VOLTAIRE

For us, the artist's freedom was like the critic's freedom: it was the capacity to be open to all experience, to shake off prejudices that kept the energies of the mind dammed up, and compelled them to flow in a single direction.

ERASMUS

You say you want aesthetic freedom governed by form. But who determines that form?

VOLTAIRE

Man himself—the artist, the critic, the instructed collector. Who better? Mastery means self-mastery.

ERASMUS

But then you are what you strenuously denied being: an existentialist!

V ON EXISTENTIALISM

LUCIAN

Existentialist! You pronounce that word, Erasmus, as though it were an epithet. Can you deny that existentialism has impressive Christian antecedents? Why do you think modern existentialists like to borrow from Christians like Pascal or Kierkegaard?

ERASMUS

They composed shapely and memorable lines that the existentialists found congenial, but what matters about them—at least to me—is not that they impressed the existentialists, but that they were Christians.

LUCIAN

But think of your sacred book: the Fall of Man is a magnificent existentialist metaphor. It was the mo-

ment that God turned His face away from man and left him, alien and alone, to confront his predicament in a meaningless world.

ERASMUS

That seems merely fanciful to me. After the Fall, man was alone in the way a disobedient son is alone: he is aware of his father's wrath and too ashamed to face his presence. To the religious man, the world has never been meaningless. Man's Fall, his need for Redemption, and his love for his Redeemer, give the Christian life the meaning that the existentialists say they cannot find. Of course they cannot find it: having turned their back on meaning, they should not bemoan its disappearance.

LUCIAN

I take it, then, that you would repudiate even those among the existentialists who explicitly call themselves Christian?

ERASMUS

They may claim me; I do not claim them. Those Christian existentialists wanted faith without a church—Protestantism gone mad. And the atheist existentialists are worse: they want freedom without boundaries—individualism gone mad; their existentialism is the superstition of the irreligious. Even you, Voltaire, will admit that existentialism is as alien to you as it is to me.

VOLTAIRE

As our old Jesuit teachers used to tell us: let us distinguish. Christian existentialism has very little

in common with our philosophy except its radical willingness to tackle hard questions.

LUCIAN

Oh? Pascal and Kierkegaard sound strikingly like philosophes; in fact, Voltaire, they sound strikingly like you.

VOLTAIRE

They were wits, like me. But their wisdom—to the extent that it *was* wisdom—was literary, the kind of wisdom one can savor for its felicity without feeling compelled to accept its message. The most interesting work the existentialists have done, and continue to do, is the play, the essay, the collection of aphorisms.

LUCIAN

Strange: that sounds like a description of your little family of philosophes.

VOLTAIRE

We wrote philosophical tales, they wrote anti-philosophical ones. Their fables said: "You must believe." Ours said: "Whatever you do, you must *not* believe." Pascal and Kierkegaard were philosophes in all but their ideas.

LUCIAN

But both Pascal and Kierkegaard attacked the clerical establishments of their day with a relish and a stylishness you would have enjoyed. In fact, you did more than enjoy it: did you not borrow freely from Pascal's attacks on the Jesuits?

VOLTAIRE

His target was well chosen. Both Pascal and Kierke-
gaard were prepared to assail churchmen, but not
Christianity—they confronted the symptom but not
the disease. To the extent that they were truly
Christian—

LUCIAN

I know: they were not enlightened.

VOLTAIRE

And to the extent that they were truly enlight-
ened—

LUCIAN

I know: they were not Christians.

VOLTAIRE

Thank you.

ERASMUS

How cavalierly you dispose of some of the world's
greatest thinkers!

VOLTAIRE

Writers, not thinkers! But I occupied myself with
Pascal at length—all my life, in fact.

LUCIAN

You did, and it is a tribute to your political sense.
But while you returned to him over and over again,

134

you read him—how shall I put it?—tenaciously but not deeply. You thought that once you had discredited his metaphors you had disproved his philosophy. He haunted you, but you never allowed his stark message to penetrate to the inner reaches of your being. You never allowed yourself to ask, "Can he after all be right?"

VOLTAIRE

Pascal did not haunt me. I respected him as one respects a formidable adversary. For the most part he wrote like an angel: a man who writes like that cannot be all bad. But respect and acceptance are two very different things. Pascal made me listen; he did not make me a Christian. I analyzed his metaphors, true, but my analysis was not a mere verbal exercise: Pascal's extravagant images revealed some rather extravagant thinking. He called London and Paris desert islands when everyone knows that they were teeming and cultivated cities.

LUCIAN

Everyone knows: exactly! Certainly Pascal knew it. You quibbled about his statement as though it were a travel report instead of an attempt to symbolize the human condition.

VOLTAIRE

Obviously! The Human Condition! The existentialist cant phrase to end all existentialist cant phrases! By patronizing me for taking Pascal literally you are falling into the very error you are

castigating me for: you are taking *me* literally. I know perfectly well what Pascal knew. I criticized his language because it seemed to me dangerously misleading about fundamental issues. And the issues between him and me *were* fundamental— they involved nothing less than, well, the human condition. I strenuously objected to Pascal's loving concentration on man's abjectness. He used a happy, fanciful picture—man, he said, is a fallen king. But he put stress not on man's royal origins; the length, the depth, of man's fall pleased him much more. He exalted man the better to depress him, and thus converted a common-sense observation into an apology for his particular superstition. I, too, wrote a fable about the human condition once. Would you like to hear it?

ERASMUS

Not really.

VOLTAIRE

Here it is: it is called *Le Monde comme il va, Ou, vision de Babouc.* The city of Persepolis had gravely displeased God with its vices and crimes, and God was determined to destroy it. But before proceeding, he sent an angel to the city. The angel found a bewildering diversity of conduct: honest judges side by side with judges who took bribes; kind fathers and brutes; faithful and faithless wives; philosophers who thought deeply and priests who fornicated freely. Seeking to give plastic expression to his observations, he had a local gold-

smith make him a little statue of a man, of gold and alloy, precious stones and clay; then he took this compound statue to God, and pleaded for the city. And God relented, for he read the meaning of the statue: if there was much evil in man, there was also much good, and if all is not for the best, all is passable.

LUCIAN

In a word, the issue that divided you and Pascal was original sin. But the atheist existentialists repudiate original sin quite as vehemently as you did. You said earlier that you could see yourself in the Romantics—well, in some of the Romantics. Can you not see yourself in the existentialists—at least in some of them?

VOLTAIRE

Again let us distinguish, and more nicely than before. I find in atheist existentialism much that is appealing and recognizable. Its radical, totally uncompromising secularism, of course. And its philosophy of courage.

ERASMUS

Appealing and recognizable, perhaps, but not your own. Its courage and yours are not the same.

VOLTAIRE

We had the courage of the existentialists without their rhetoric. Think of the devotion of Diderot, reading out his eyes with proofs for the *Encyclo-*

pédie, the patience of Lessing, founding modern German literature almost singlehanded, the public service of Turgot—

LUCIAN

Far be it from me to take them lightly, but these are not instances of existentialist courage. They are instances of energy and diligence. The existentialists confront graver issues: man face to face with the absurd, or with extreme situations.

VOLTAIRE

Like death?

ERASMUS

Like death.

VOLTAIRE

We died bravely.

ERASMUS

Many Christians died bravely.

VOLTAIRE

I suppose many of you died quietly; though, with the prospect of eternal bliss before you, there was little enough of bravery in it. But that is not the point: I am not concerned to deny that Christians die well; I am only concerned to assert that one can die well without being a Christian—and without being an existentialist. Think of the death of Hume and, may I add, my own, worthy of the ancient Stoics—

ERASMUS

To say nothing of Rousseau's love life and, may I
add, your own, worthy of modern Epicureans.

VOLTAIRE

We were subject to the human condition in this too!
But forget about me if you wish, and let me tell you
about David Hume. He had been cheerful and cor-
pulent, but, beginning in 1772, he lost weight in
alarming fashion and came to recognize soon
enough that he was mortally ill. He carried this
awful knowledge about with him for perhaps three
years. He grew frail and thin, a shadow of his
rotund self. But his cheerfulness, and his considera-
tion for others, did not diminish. He whiled away
his time reading his favorite pagan writers, who
had all had much to say about death. He read
Lucretius and he read you, Lucian, with deep pleas-
ure, and amused himself making up new dialogues
of the dead—after you. Then in July of 1776, seven
weeks before his death, when his prospective dis-
solution was obvious to all, James Boswell came
to see him. Boswell was a great biographer and a
great sensualist; a typical Christian: he sinned,
suffered, repented, hoped to be forgiven, and sinned
again. Well, he tried to bedevil the dying Hume
with his intrusive questions. He asked him if he
was sure there was no afterlife, asked him—good
taste was never Boswell's specialty—if he did not
regret never seeing his old friends again, and if the
thought of eternal annihilation did not make him
uneasy. No, Hume said; this sort of thing did not

trouble him; he was facing his end with perfect serenity. To Boswell's horror, Hume's confident demeanor bore out his words. Disconcerted, defeated, Boswell left hurriedly. He was in the flush of good health, but the dying philosopher had been stronger than he. Hume was a free man.

LUCIAN

But is this existentialist freedom?

VOLTAIRE

Not really. Unlike the existentialists, we philosophes did not divorce man from nature. We held radical subjectivity to be a fatal defect, not a desirable ideal. We thought some laws, many ideas, and all supernatural religions absurd, but not the universe as a whole; we thought much philosophy meaningless, but not life itself. Some of us believed that man lives in a God-forsaken, others that he lives in a God-less, world, but these convictions did not drive us to fear and trembling, or induce nausea. We believed—do you remember? we talked about it—that man has a nature; the existentialists insist that man's existence precedes, and shapes, his essence. In a word, we did not believe that man chooses himself, but that he finds his freedom within a network of the given; we did not, like Dostoyevsky's man from underground—a great favorite with the existentialists, I believe—defy the laws of nature, and refuse to be reconciled to them; we listened to Bacon and sought to obey nature that we might dominate her. And their language!

ERASMUS

For once I see we agree: all that nauseating talk of filth, that depressing talk of care and anxiety!

VOLTAIRE

I mind the depressing talk more than the nauseating talk: a little candid obscenity is a boon to man. But most of all I mind the seductive power of existentialist language—its power, especially, over the young, who have not yet learned to distrust what excites them, and who think that what is brilliant must be true. The young are nihilists and anarchists by nature: why encourage them? Why license their outbursts of feeling with solemn philosophical arguments? Existentialism is the philosophy that gives good reasons for being unreasonable. You all know the consequences: with perfect good will, with a frightful and frightening purity, the young fight good causes with bad methods, and invite the most dreadful disillusionment by exaggerating the wickedness of the world, and overestimating their power to set it right.

ERASMUS

For all your disclaimers, had you lived in the twentieth century, you would have been existentialists to a man—atheist existentialists, of course.

VOLTAIRE

Not at all. A few of us might have been: after all, those of us who survived into the French Revolution found ourselves in many camps. But you forget

that many of us were not atheists. And even the
atheists among us, with their confidence in the ulti-
mate possibilities of intelligence, their commitment
to form, their sense of kinship with nature, and
their urge toward objectivity, would doubtless have
refused to join the existentialists. We would have
been Naturalists, Realists, Pragmatists, Marxists
perhaps—very independent-minded Marxists, Logi-
cal Positivists certainly.

ERASMUS

I can believe it. Logical Positivists: the philoso-
phers who seek to destroy all philosophy, and to
evade all problems by denying that they exist. Who
was it who said, "Les Philosophes were not phi-
losophers"? He was right.

VOLTAIRE

He was wrong, as you are wrong. The defects of
logical positivism are better known than its vir-
tues. At worst, it displayed a kind of sublime
arrogance—

ERASMUS

As you did—

VOLTAIRE

As we did, at worst. At best, it continued the kind
of liberating intellectual work, rubbish-clearing,
that we did, at *our* best. Like those Marxists free
from partisan fury or sentimental attachment, the
logical positivists carried the torch of analysis
into dark corners and showed that the most pro-

found mysteries of metaphysics were nothing more than cobwebs of the mind. But my point is not to claim a single descendant when, so obviously, we had many descendants. The intellectual style of the Enlightenment was large enough to nourish many schools of philosophy. It was itself, after all, not a school: its eclecticism was deliberate and triumphant. Our intellectual style was hostile to many modes of thought—to all those that live by myths and teach that the examined life is not worth living —and hospitable to other modes—to all those that regard everything subject to criticism.

ERASMUS

Criticism is not enough. I find much to admire in your conduct, and some of your arguments—some! —convincing. But what divides us, and will always divide us, I think, is your essential destructiveness.

VOLTAIRE

I thank you even if I disagree with you. One of the most infuriating slanders against us has been that we were humanitarians from suppressed rage, from sheer *ressentiment,* that we loved everybody because we really loved nobody. Actually, we were good haters; there was much in the world we found it impossible to love. We knew how to love precisely because we knew how to hate. In calling us destructive, you have captured at most half of our thought.

ERASMUS

I think I have captured all of it. I would be the last to criticize you because you proclaimed uncomfort-

able truths: I did a great deal in my time to make men uncomfortable. Nor do I think that you should have invented moral certitudes just to provide weak spirits with the reassurance they craved. But how much has your philosophy done for man?

VOLTAIRE

We began our conversations with Gibbon. Perhaps we can end with him. What he criticized us for doing—exposing an old superstition for what it was —was, in fact, fulfilling our highest obligation. In seeking to make criticism prevail, even in the sensitive area of religion, we advocated the kind of thinking appropriate neither to fools nor to cowards, neither to slaves nor to children, but to men. To make criticism prevail was to fight for man's dignity. How much did our philosophy do for man? It took away his crutches and taught him to walk for himself.

ERASMUS

He has fallen often enough since to prove how badly he needs the support you took from him. As I told you before: in its most perverted and most extravagant forms, Christianity at least offered man consolation. In its pure form it offered him this consolation as the saving truth. In your indiscriminate assault on all Christianity, you destroyed the essence along with the excrescences of religion. And in this way you cast man into the tossing seas of uncertainty.

VOLTAIRE

All men do not need certainty. Gibbon did not need it. Hume did not need it. We philosophes in general did not need it. And we hoped by our propaganda to enlarge the circle of philosophes—that is, of men who do not need certainty.

ERASMUS

Hume was an exception, almost a kind of monster. But the rest of you concealed your hunger for certainty behind your clever impious formulas: behind materialism, with its chilly, vulgar cult of nature; behind deism, with its simple-minded notion of the divine watchmaker—a fine set of dogmas: religions for unbelievers. No wonder your substitutes crumbled, as they had to, from lack of nourishment. Are you surprised that the existentialists—with their talk of despair and anxiety and dread and alienation—moved into the vacuum you had made? I repeat my question: Has your philosophy ever provided man with shelter against the icy blasts of a cruel or, worse, an indifferent universe? I ask that question as a Christian, but some of your most sympathetic twentieth-century readers have asked it too. Carl Becker thought that you offered man no basis for distinguishing between good and evil, no incentive for doing right. And Alfred North Whitehead, as well disposed toward you as Carl Becker was, said that "if men cannot live on bread alone, still less can they do so on disinfectants"—and he said it about you. You may take pride in your criticism, but I repeat: criticism is not enough.

Our criticism was more than criticism. It was a method—the essential expression of a style of thinking, and of a view of man. I come back to what I said in an earlier conversation, only more confidently than before. It is a cliché, I know—I made it into a cliché—but it is true to say that we destroyed in order to build. We honored man's nature and recognized its limitations, but the point is that we honored it. What you call our destructiveness is evidence of our respect for man: we thought he deserved better than the childish, bloodthirsty stories told by priests and kings.

ERASMUS

Can you look at man in the twentieth century and keep your respect intact?

VOLTAIRE

Our respect is for man's possibilities. Erasmus, you have spoken eloquently of the horrors of the twentieth century. I did not contradict you, for I thought your catalogue, if harsh, just enough. But that catalogue proves, if it proves anything, a continuing need for our method and our program alike. We wanted a secular society: religious men continue to obstruct the progress of learning and science everywhere, more subtly perhaps, but effectively still. We wanted humane treatment of accused persons: if I were to reappear in the twentieth century, how many innocent victims of injustice would I have to defend? We wanted free expression: it is a cause

needing continual vigilance. We wanted an end to slavery: politicians have thought up new forms of slavery we did not even dream of. We wanted peace: today the need for peace is more desperate than it was in our time. If you would compile a program of reform from the writings of Montesquieu and Lessing and Beccaria and Bentham—and from my own —you would have a program singularly appropriate to the world of the twentieth century.

LUCIAN

In its aims, doubtless. But your solutions are far too feeble to work. Erasmus said that criticism is not enough. I say, *your* criticism was not enough. It is not merely that the vices of the modern age are more resistant to treatment than you thought. What is far more damaging is that there were vices you did not imagine, and thus could not criticize. You have admitted that there are forms of slavery you did not dream of. There is deceit you did not dream of, exploitation you did not dream of, cruelty you did not dream of. Men have been made into accomplices to their own destruction. They have been victimized by shrewd manipulators who give them meaningless concessions—a little more money, a so-called free electoral system, and deafening, soul-destroying entertainment. And what has been the result? Men have been numbed until they demand neither genuine benefits nor real power. They feel pleasure when they should be feeling pain. Your criticism was not enough. Many of the reforms you wanted have been enacted and mutilated in their very enactment. What good is

prosperity if all men have the same taste? What good is a free press if all newspapers print the same opinions? Your program was not enough. Let me put it differently: you were liberals, and if history holds any lesson at all, it is that liberalism is not enough.

VOLTAIRE

What you call our liberalism was not a rigid list of demands but a comprehensive attitude toward politics. To fight for freedom against a feudal lord or a modern dictator is the same good liberal fight. To fight for dignity against eighteenth-century priests or twentieth-century exploiters is the same good liberal fight. To fight for truth against the professional liars of all ages—against censors, merchants, politicians—is the same good liberal fight. Only the details of the fight change. Our proposals were for our time: that is what made them so meaningful. Twentieth-century philosophes must develop their own proposals, meaningful to their time.

LUCIAN

I share many of your wishes but none of your hopes. And you misunderstand me: when I said that liberalism is not enough, I was referring not to your political program but to its underlying philosophy. Earlier you called the Enlightenment a revolt against rationalism, insisted that it gave room to the passions, and showed that it was not particularly optimistic. These were all welcome corrections of a powerful and persistent caricature. But I

wondered then, and nothing you have said since has reassured me: how seriously did you really take these insights? Did you merely play with irrationalism and pessimism? That is why I found your treatment of Pascal so unsatisfactory, and I—need I remind you?—I am not a Christian. I am not speaking of your detailed predictions, nor about nuances of optimism. I am speaking of principles. Shade it as you like, lay on the dark strokes as thickly as you can, your portrait of man remains a sunny pastel. Your philosophy did not equip you to see what has been called the everlasting No at the heart of life. You were hopeless—that is to say, hopeful—reformers; as a twentieth-century critic might say: you were incurable social democrats. You were among the most energetic and effective enemies of myths the world has ever seen, and I honor you for that. But you had a myth of your own, an unexamined and unfounded assumption: that it is possible to improve man's lot by man's intelligent action. That was your liberalism, and that is why I said that liberalism is not enough.

VOLTAIRE

In the end, after all experimentation and investigation are over, philosophy rests on a wager. Pascal advised the doubter to wager on God's existence. I advise man to wager on the possibility of improvement. I am repeating myself, I know. I am returning to the story of the farmer with his three sons. But you are repeating yourself as well—clearly it is time to conclude. I am not pleading for some blind will to believe, some delusive hope that things will

get better if we only want them strongly enough. I am saying only that if our method should fail —that critical method which, as I said, is more than a method—everything else must fail as well, and more drastically. And even our method is open to perfection. I said it before: critical thinking fearlessly confronts everything, including itself. As methods require refinement, so criticism invites criticism of itself. I am not foolish enough, self-important enough—shall I say, bigoted enough?—to call for imitators in the twentieth century. Our true admirers will prove their admiration by going beyond us. What the Enlightenment did, in its destructive and its constructive work alike, was to show man the way to autonomy, which is the freedom to obey the rational laws one has made for oneself—freely; and, I think despite your doubts, the courage to understand the world in which one lives, and to reject half-solutions or deceptive compromises. A philosophy can do no more and should do no less. We did no less, and we never boasted that we had done more. That is why, far from failing to offer modern man a basis for morals and an incentive for action, we offered him the *only* basis on which he can live with dignity. Far from feeding man on disinfectants, we offered him the water that gives clarity and the wine that gives energy; it should be enough. Earlier you said, Lucian, that you felt closer to me than to Erasmus. That was placing our Enlightenment where it belonged. Yours was an age of criticism, so was ours. Criticism was a bridge we threw to you across the swamp of belief. What I have tried to do in these conversations

has been to build another span, from our century to
the twentieth, and to show that it will hold firm. I
am confident that it will.

ERASMUS

The bridge of unbelief? It will only lead men to
hell—if it holds.

LUCIAN

I dare not hope, just as you, Erasmus, need not
fear. We must act as though it will hold—I know.
But what bridge, built by reason, has ever held
before?

NOTES

NOTES

I wrote these dialogues to serve two distinct but related purposes: to show the continuing vitality of the Enlightenment and to rescue it from some persistent misreadings. These purposes are, of course, inseparable: it is only when we know what the Enlightenment was that we can adequately understand what it can still do. The point of these notes is to amplify the information that the speakers sometimes give only sketchily, to identify both visible and invisible quotations, to record my indebtedness, and to give the reader an opportunity to look further by giving him some bibliographical indications. These indications are, of course, quite scanty; I have tried to establish the contours of the Enlightenment in several books, all of which are amply documented. I shall refer to these books in the notes, by abbreviations: *Voltaire's Politics: The Poet as Realist* (1959), as *V.; The Party of Humanity: Essays in the French Enlightenment* (1964), as *P.; The Enlightenment: An Interpretation,* volume I, *The Rise of Modern Paganism* (1966), as *E., I;* and *The En-*

lightenment: An Interpretation, volume II, *The Science of Freedom* (1969), as *E., II.*

I. ON MODERNITY

p. ix *Gibbon's plan of writing a dialogue of the dead.* See *Autobiography* (ed. Dero A. Saunders, 1961), 203.

p. 5 *Voltaire as prudential liar.* Lying for the sake of freedom, for the sake of publishing views that might offend dominant religious or political orthodoxy, was a serious tactical but scarcely a moral problem for the philosophes. Except for Rousseau, who signed everything he wrote and suffered for it, the other philosophes, even the scrupulous ones, did not hesitate to pass off their works as the writings of authors long since dead or, unimpeachably pious, to have their books printed abroad or clandestinely at home. Some of the philosophes, of course, including Voltaire, rather enjoyed the sport. "A lie is a vice only when it does harm," he wrote to a friend in 1736, when the secret of his authorship of one of his plays was in danger. "It is a very great virtue when it does good. So be more virtuous than ever. You must lie like a devil, not timidly, not for a while, but boldly, and all the time. . . . Lie, my friends, lie. I shall repay you when I get the chance." To Thieriot, October 28, 1736. *Voltaire's Correspondence,* 107 vols. (ed. Theodore Besterman, 1953–1965), V, 286–287. See *V.,* 66–87, and *E., II,* ch. II, section 1.

p. 6 *Lucian and his admirers.* Satirists through the centuries —including Voltaire and Erasmus—made Lucian into their favorite. Even Gibbon, before the French Revolution frightened him into repudiating, or at least regretting, some of his own bold notions, praised Lucian for "exposing the idle tales of the poets and the incoherent traditions of antiquity" with his satire, "a much more adequate as well as more efficacious weapon" than Cicero's reason and eloquence in the same cause. *The History of the Decline and Fall of the Roman Empire,* 7 vols. (ed. J. B. Bury,

1896–1902), I, 30. For Lucian, dialogue was the enemy
of rhetoric, and passed for the son of philosophy. For his
other followers, see Francis G. Allinson, *Lucian: Sati-
rist and Artist* (1926), and Ludwig Schenk, *Lukian und
die französische Literatur im Zeitalter der Aufklärung*
(1931).

p. 7 *Philosophes as fanatics.* I have polemicized against this
view in *P.*, 279–286; so has Alfred Cobban, *In Search of
Humanity: The Role of the Enlightenment in Modern
History* (1960), 181–184. It remains a popular view.

p. 11 *Enlightenment as an age of criticism.* "Facts," Diderot
wrote, "may be distributed into three classes: the acts of
divinity, the phenomena of nature, and the actions of men.
The first belong to theology, the second to philosophy, and
the last to history properly speaking. All are equally sub-
ject to criticism." Article *"Fait"* in the *Encyclopédie*, in
Diderot, *Œuvres complètes*, 20 vols. (eds. Jules Assézat
and Maurice Tourneux, 1875–1877), XV, 3. I find myself
in agreement with Ernst Cassirer's important discussion
of this issue, in his *The Philosophy of the Enlightenment*
(1932, trs. F. C. A. Koelln and J. P. Pettegrove, 1951),
ch. I, and ch. VII, part 1. See also *E., I*, ch. III.

p. 13 *Philosophes as modern pagans.* I have argued that nearly
all philosophes underwent the same development: they
grew up in Christian households, went to Christian
schools and came to repudiate the Christianity they had
learned there by means of the classics they had acquired
in the same place—hence "pagans." But eventually they
broke loose from their classical education (without sur-
rendering their affection for the classics) and developed
their own thought—hence "modern pagans." See *E., I*.

p. 16 *Philosophes as family.* I have borrowed the notion from
Ludwig Wittgenstein; it has become a commonplace in
philosophy, but is intensely useful in history, particularly
in the history of collectivities.

p. 21 *Irrelevance through success.* "If the characteristic
eighteenth-century outlook fails to excite or stimulate
today, it is partly because its exponents have done their

work so well and successfully. What they preached has become common ground, shared even by the successors of their erstwhile opponents." E. A. Gellner, "French Eighteenth-Century Materialism," in D. J. O'Connor, *A Critical History of Western Philosophy* (1964), 281. The whole article is at 278–295.

p. 25 *Elements missing in the thought of the Enlightenment.* Three of these are discussed in Gellner's article cited just above; I am indebted to it. A fourth, the creative imagination, is my addition.

II. ON HISTORY

p. 31 *Historicism.* Among the many discussions of this movement the most important and influential remains Friedrich Meinecke, *Die Entstehung des Historismus,* 2 vols. (1936). It has never really received the full-scale critique it needs: it is complacent about the achievement of Ranke and his followers and, conversely, schematic and censorious about the failings of Ranke's eighteenth-century predecessors. For a brief assessment of the Enlightenment's historical work, see *E., II,* ch. VII, section 4.

p. 33 *Hume: "I believe this is the historical Age."* ". . . and this," he added, singling out the Scots for special praise, "the historical Nation." To William Strahan, August 1770. *The Letters of David Hume,* 2 vols. (ed. J. Y. T. Greig, 1932), II, 230.

p. 33 *"Erudition, diligence, veracity, and scrupulous minuteness."* Voltaire is indeed quoting Gibbon; Gibbon is praising, in his incomparably snide manner, the pious and scholarly church historian Tillemont, "that incomparable guide—whose bigotry is overbalanced by the merits of erudition, diligence, veracity, and scrupulous minuteness." *Decline and Fall of the Roman Empire,* V, 132n.

p. 34 *"We need the truth in the smallest things."* Voltaire, *Le Siècle de Louis XIV,* in *Œuvres historiques* (ed. René Pomeau, 1957), 878n.

p. 35 *Hume's universal unpopularity.* "I thought that I was the only historian, that had at once neglected present power, interest, and authority, and the cry of popular prejudices," Hume writes in his short autobiography, but instead he found himself "assailed by one cry of reproach, disapprobation, and even detestation; English, Scotch, and Irish, Whig and Tory, churchman and sectary, free-thinker and religionist, patriot and courtier, united in their rage against the man, who had presumed to shed a generous tear for the fate of Charles I and the Earl of Strafford." *My Own Life,* in *Philosophical Works of David Hume,* 4 vols. (eds. T. H. Green and T. H. Grose, edn. 1882), III, 4–5. Unpopularity is an appealing criterion, but not without its risks.

p. 35 *Voltaire on scientific history.* "History must be neither a satir nor an encomium." Voltaire to Richard Rolt, August 1, 1750, in English. *Correspondence,* XVIII, 108. Voltaire actually used the phrase, *"la science de l'histoire."* See *Remarques pour servir de supplément à L'Essai sur les mœurs,'* in *Essai sur les mœurs,* 2 vols. (ed. René Pomeau, 1963), II, 900.

p. 37 *Pious chroniclers in the service of unbelief.* See *E., I,* ch. VII, section 1, where I give a number of instances.

p. 39 *Voyages of historical discovery.* This extravagant metaphor is a reminiscence of Carl Becker's *The Heavenly City of the Eighteenth Century Philosophers* (1932), 105.

p. 39 *"Mankind are so much the same, in all times and places."* This statement of David Hume's from *An Enquiry Concerning Human Understanding,* in *Works,* IV, 68, has been much abused by being quoted in isolation. See, for one example, Becker, *Heavenly City,* 95.

p. 41 *The ideal historian as fearless, incorruptible, etc.* This passage is indeed a close paraphrase from Lucian's essay, "The Way to Write History."

p. 43 *Hume on the sources of all actions.* See *An Enquiry Concerning Human Understanding,* in *Works,* IV, 68.

p. 44 *Locke on the soul:* As Voltaire put it in his celebrated report on England: other philosophers had written the

"romance of the soul," Locke came along and "modestly wrote its history." As for himself, Voltaire added, "I boast of the honor of being as stupid on this point as Locke." Lettre XIII, in *Lettres philosophiques,* 2 vols. (ed. Gustave Lanson, 1909), I, 168–169. This is one instance of what the philosophes liked to call "philosophical modesty," the concentration on things that could be known and a deliberate neglect of things that would forever remain obscure.

p. 44 *Hume on revolutions in human affairs.* See "Of Civil Liberty," *Works,* III, 157; and "Of Eloquence," *ibid.,* 163.

p. 46 *Diderot on man's heart as being both sanctuary and sewer.* To Falconet, May 15, 1767. In *Correspondance,* 13 vols. so far (ed. Georges Roth, 1955——), VII, 59.

p. 46 *Saint-Évremond.* This passage is quoted in Henry Vyverberg, *Historical Pessimism in the French Enlightenment* (1958), 31.

p. 47 *Historical relativism among the philosophes.* Even if their practice did not match their pronouncements, their pronouncements show that the philosophes were perfectly aware of the need for historical sympathy with other ages. "Would you try a GREEK or ROMAN by the common law of ENGLAND?" David Hume asked. "Hear him defend himself by his own maxims; and then pronounce." Indeed, "there are no manners so innocent or reasonable, but may be rendered odious or ridiculous, if measured by a standard, unknown to the persons." *A Dialogue,* in *Works,* IV, 294. For other instances, see *E., II,* 380–383.

p. 51 *Philosophes destroying in order to build.* This was a leading notion in the Enlightenment, a much-used metaphor. The Enlightenment, Ernst Cassirer notes, "joined, to a degree scarcely ever achieved before, the critical with the productive function and converted the one directly into the other." *Philosophy of the Enlightenment,* 278. At the same time, in its aggressive posture, the Enlightenment certainly stressed the need for radical rooting up. Voltaire spoke of Christianity as a poisonous tree that must be uprooted; piqued by the charge that he was being merely

destructive, he replied that a wild beast threatening one's family can only be killed.

p. 52 *Philosophes' uncertainty.* I have amassed a good deal of evidence of the philosophes' private struggles in *E., I,* especially Overture and ch. I, but more work can profitably be done on the inner history of these dissenters.

p. 54 *Philosophes as cultural historians.* In addition to his own essays in cultural history, Voltaire laid down a whole program: "I should like to learn just what was the strength of a country before a war, and if the war had increased or diminished it. Was Spain richer before the conquest of the New World than today?" Why did the population of Amsterdam grow in two hundred years from twenty thousand to two hundred and forty thousand? How did the arts and manufacturing establish themselves in one country and move from one country to another? See *Nouvelles considérations sur l'histoire,* in *Œuvres historiques,* 46–48. And again: "A lock on a canal that joins the two seas, a painting by Poussin, a fine tragedy, are things a thousand times more precious than all the court annals and all the campaign reports put together." Quoted in J. H. Brumfitt, *Voltaire Historian* (1958), 46. The heart of modern cultural history is contained in these observations.

p. 56 *D'Alembert on the Renaissance.* Other historians in the Enlightenment could be quite as naïve. In his *The Idea of History* (1946), 80, R. G. Collingwood accordingly charges the philosophe-historians with a "pragmatic" view of historical causation—the simple-minded view that small causes cause great events. But even on the question of the Renaissance d'Alembert was by no means typical. The philosophes did not have a sophisticated theory of historical causation, but they were far better than mere pragmatic historians. See *E., II,* 386–391.

p. 57 *Hume on Charles I.* See Hume's *The History of England,* 8 vols. (edn. 1780), VII, 146.

p. 61 *Hume on the medieval Jews.* See *History of England,* II, 240ff.

III. ON OPTIMISM

p. 72 *The oldest slander against the Enlightenment.* The only way to convince oneself that the philosophes were after all not naïve and incurable optimists is to read them. See *E. II,* ch. II; Vyverberg, *Historical Pessimism in the French Enlightenment,* a rich bouquet of gloomy quotations; and see note to p. 74 below.

p. 72 *"If this is the best of all possible worlds, what are the others like?"* As the other speakers readily recognize, this plaintive query is from Voltaire's *Candide,* ch. 6.

p. 73 *Christian optimism.* This, to be sure, took some extreme forms, including apocalyptic predictions and millennial Utopianism, and mild forms, including confidence in divine generosity with human lapses. On this matter, which needs to be understood if the philosophes' own hopes are to be put into some perspective, I direct the reader to Ernest Lee Tuveson, *Millennium and Utopia: A Study in the Background of Progress* (1949); R. J. Crane, "Anglican Apologetics and the Idea of Progress, 1699–1745," *Modern Philology,* XXXI, 3 (February 1934), 273–306, and 4 (May 1934), 349–382; Theodor E. Mommsen, "St. Augustine and the Christian Idea of Progress," *Journal of the History of Ideas,* XII, 3 (July 1951), 346–374; and the interesting if still controversial book by Norman Cohn, *The Pursuit of the Millennium* (2nd ed., 1961).

p. 74 *Instances of philosophes' pessimism.* Voltaire's "everything has its limits" comes from *Le Siècle de Louis XIV* in *Œuvres historiques,* 1016–1017. Hume's "No advantages . . . are pure and unmixed" can be supplemented by: *"When the arts and sciences come to perfection in any state, from that moment they naturally, or rather necessarily decline, and seldom or never revive in that nation, where they formerly flourished."* See "Of the Rise and Progress in the Arts and Sciences," *Works,* III, 191, 195. And: "Death is unavoidable to the political as well as to the animal body." "Whether the British Government Inclines more to Absolute Monarchy or to a Republic,"

ibid., 125–126. Montesquieu's "Almost all the nations . . . travel this circle" is quoted in Vyverberg, *Historical Pessimism,* 155. Vyverberg also has this passage from Condillac: "Sooner or later, luxury ruins those nations into which it has insinuated itself." *Ibid.,* 129. What Voltaire calls "the law of compensation"—that every advance must be somehow paid for—runs through the Enlightenment as a whole, and has eloquent and persistent spokesmen particularly in the German *Aufklärung.* "Has it not always been obvious," Wieland rhetorically inquires, "that the time of highest refinement is precisely the time of the most extreme moral rottenness? that the epoch of brightest enlightenment is always the very epoch in which all sorts of speculations, madness, and enthusiasm, flourish most?" Quoted in Friedrich Sengle, *Christoph Martin Wieland* (1949), epigraph.

p. 75 *"It is unlikely that civilization will relapse . . ."* This is a paraphrase from Gibbon: "We cannot determine to what height the human species may aspire in their advances towards perfection, but it may safely be presumed that no people, unless the face of nature is changed, will relapse into their original barbarism." *Decline and Fall of the Roman Empire,* IV, 167–168.

p. 75 *"Culture might change countries . . ."* See Diderot to Princess Dashkoff, April 3, 1771: "Enlightenment can move from country to country, but it cannot be extinguished." *Correspondance,* XI, 21.

p. 78 *Optimism as appropriate response to the eighteenth century.* I have developed this point at length in *E., II,* chs. I and II.

p. 80 *Diderot said—.* "It is quite certain that we are not so barbarous as our forefathers. We are more enlightened. Are we better? That is another question." To Madame de Maux, May 1769. *Correspondance,* IX, 61. While it is easy to show that Diderot did not keep this view consistently in mind (see *E., II,* 123n), that he could reach it at all is highly significant for our estimate of the philosophes' "optimism."

p. 80 *The abuse of knowledge.* Most instructive are: Condorcet's

Esquisse on progress, with its portraits of statesmen and priests and physicians monopolizing knowledge for the exclusive advantage of their sects and clans; Gibbon's cynical description of the arcane techniques of the Roman emperors, preaching to the masses a religious faith that they did not believe; and Bentham's theory of "sinister interest," which keeps those who know from disseminating their knowledge.

p. 84 *Man sees the better and chooses the worse.* See Moses Mendelssohn: "Video meliora proboque etc. Who does not know this saying without knowing that it is very difficult to reconcile with any philosophical system whatever? Yet to my mind nothing is more natural." Reason may see that course A is good, but "dark forces of the soul" drive man to follow course B. From Mendelssohn, "Von der Herrschaft über die Neigungen," quoted in Robert Petsch, ed., *Lessings Briefwechsel mit Mendelssohn und Nicolai über das Trauerspiel* (1910), 130. Diderot wrote in his posthumously published *Pages contre un tyran* (written in 1771): All men "can say with Medea: *video meliora proboque, deteriora sequor.*" Diderot, *Œuvres politiques* (ed. Paul Vernière, 1963), 136. And Diderot's extensive discussions of the powers of the passions point in the same direction.

p. 87 *George Bernard Shaw.* See Shaw's "Don Juan in Hell," which forms Act III of *Man and Superman.*

p. 88 *Revolt against Rationalism.* I have documented this revolt in detail in *E., II,* ch. IV, section 3. The two passions to which the philosophes paid the closest and most admiring attention were pride and sensuality. But other passions also engaged their analytical powers.

p. 89 *Hume: "Reason is and ought only to be the slave of the passions."* See *Treatise of Human Nature* (1739–1740, edn. 1888), 415. And see Diderot: "People ceaselessly proclaim against the passions, people impute to the passions all of man's pains, and forget that they are also the source of all his pleasures. It is an element of man's constitution of which we can say neither too many favorable, nor too many unfavorable things. . . . It is only the

passions, and the great passions, that can raise the soul to great things." *Pensées philosophiques,* in *Œuvres,* I, 127.

p. 90 *Anticipations of Freud.* The German *Aufklärer* Georg Christoph Lichtenberg recommended the scientific study of dreams (see Franz Mautner and Henry Hatfield, eds., *The Lichtenberg Reader* [1959], 70); Diderot, much to Freud's pleasure, formulated the Œdipus complex ("If your little savage were left to himself," the "I" of *Le neveu de Rameau* says to Rameau's nephew, "keeping all his childish foolishness and joining the bit of rationality of the infant in the cradle to the violent passions of the man of thirty, he would strangle his father and sleep with his mother." *Le neveu de Rameau* [ed. Jean Fabre, 1950], 95); and Diderot, along with La Mettrie, as, more obliquely before him, Jonathan Swift, glimpsed the sexual origins of moral ideas: "There is a bit of testicle at the bottom of our most sublime sentiments and most refined tenderness." Diderot to Damilaville, November 3, 1760. *Correspondance,* III, 216.

p. 92 *Freud: "Science is no illusion."* See *The Future of an Illusion* (1927), in *The Standard Edition of the Complete Psychological Works of Sigmund Freud,* XXI (1961), 56.

p. 95 *The farmer and his three sons.* It is an old fable; in the eighteenth century it was printed once again by Adam Smith in his *The Theory of Moral Sentiments* (1759, edn. 1966), 263–264.

IV. ON IMAGINATION

p. 101 *Greuze.* Diderot's taste for Greuze, painter of sentimental genre scenes, nearly all of them titillating, nearly all of them showing nubile young girls in dishabille, has long been a source of some embarrassment to Diderot's admirers. Diderot called Greuze a moral painter, but there is good evidence that he liked Greuze precisely because he was just slightly immoral. Studying Greuze's famous *L'Accordée de village,* a group showing a peasant paying the dowry of his daughter, Diderot does not fail to notice

that the young girl has "a charming figure," and is "very beautiful." And even though she is modestly dressed, concealing her bosom, Diderot is led to speculate: "I bet that there is nothing there lifting it up, it holds itself up by itself." Diderot was by all odds the oddest modern Stoic I know. See "Salon of 1761," in *Salons, 1759, 1761, 1763* (eds. Jean Seznec and Jean Adhémar, 1957), 142. See also *E., II*, 203–204.

p. 102 *Leibniz and the creative imagination.* This idea, captured by the Romantics, was certainly not the philosophes' dominant view of the imagination. Surely Erasmus' objections to Voltaire's claims are wholly justified. If the philosophes were in any sense the fathers of modern psychology, it is only in the sense that their general attitude promoted the scientific study of the mind. Their theories, as Lucian rightly says (p. 104), are only of historical interest today.

p. 103 *The Enlightenment as a silver age in the arts.* Voltaire was practically obsessive about this. In *Le Siècle de Louis XIV* he speaks of the magnificent achievement of tragic authors, of La Fontaine, of pulpit orators, and suggests that once they had reached a certain perfection, they became commonplace. "After that one is reduced to imitation or eccentricity. . . . Genius has only one century; after that, everything must degenerate." *Œuvres historiques,* 1016–1017. (See also above, p. 74.)

p. 105 *Philosophes as neoclassicists.* I have explored the ramifications of this issue in *E., II,* ch. v, section 3. In his own day, certainly, Voltaire was considered not a traditionalist but a radical. "One must be novel," he wrote, "without being bizarre, often sublime, and always natural." *Candide,* in *Œuvres,* XXI, 192. Gustave Lanson's old, brief biography, *Voltaire* (1906, tr. Robert A. Wagoner, 1966), 75–92, is very good on this radicalism.

p. 108 *Diderot's pronouncements on the arts.* Diderot's aesthetics have been widely and vigorously canvassed, and rightly so: they are difficult to make coherent and at the same time (and perhaps for the same reason) eminently fertile. My

own treatment (*E., II,* ch. vi, section 1) differs from the others in stressing the development of his thinking, but I learned much, above all, from Herbert Dieckmann, *Cinq leçons sur Diderot* (1959); Leo Spitzer, "The Style of Diderot," in his *Linguistics and Literary History* (1948); Georges May, *Quatre visages de Denis Diderot* (1951); and Albert Dresdner, *Die Kunstkritik: Ihre Geschichte und Theorie,* vol. I, *Die Entstehung der Kunstkritik* (1915).

p. 111 *Romantics on the failings of the enlightened view of the imagination.* There is a comprehensive summary of Romantic charges against the "deadly," "prosaic" eighteenth century in ch. v of Alfred North Whitehead, *Science and the Modern World* (1925), presented quite uncritically as though it were the truth instead of sheer partisanship. For a corrective, see Marjorie Hope Nicolson, *Newton Demands the Muse* (1946). It seems to me absolutely undeniable that Newtonianism and eighteenth-century philosophy were anything but hostile to poetry.

p. 112 *Benjamin Haydon's dinner.* See *The Autobiography and Memoirs of Benjamin Haydon,* ed. Aldous Huxley, 2 vols. (1926), I, 269; and Nicolson, *Newton Demands the Muse,* 1–2.

p. 114 *Wordsworth on "the habit of analysing, decomposing, and anatomizing."* See M. H. Abrams, *The Mirror and the Lamp: Romantic Theory and the Critical Tradition* (1958), 310. Wordsworth's famous line, "we murder to dissect," quoted just a little before, comes from his poem, "The Tables Turned," which also contains that anti-intellectual assault on "our meddling intellect."

p. 114 *Romanticism as the heir of the Enlightenment.* While Voltaire's brief exposition of this paradoxical-sounding view seems to me wholly just, it points toward an area that is far from settled and calls for much further study.

p. 116 *Rousseau as a member of the "family" of philosophes.* For the last half-century or so, the scholar's Rousseau has not been the popular Rousseau, and the gap remains wide. The overwhelming scholarly consensus (a consensus I share)

is that Rousseau was not a "Romantic," or "Pre-Romantic" (that lazy man's label that evades all hard questions), but a philosophe. The bibliography is too vast to be cited here; I refer the interested reader to my essay, "Reading About Rousseau," *V.*, 211–261; to *E.*, *II*, ch. x, section 3, and to the bibliography in the same volume (pp. 694–700).

p. 116 *Rousseau on Plato's Republic.* "If you want a good idea of what public education is, read Plato's *Republic*. This is by no means a work on politics, as those who judge books only by their titles like to think: it is the finest treatise on education ever written." *Émile* (Garnier edn., N.D.), 10.

p. 118 *Hume on the critic.* See "Of the Standard of Taste" (1757), *Works*, III, 266–284.

p. 122 *Diderot on Voltaire's learning.* "What is it that particularly distinguishes Voltaire from all our young writers? Learning. Voltaire knows a great deal, and our young poets are ignorant. The work of Voltaire is full of matter, their works are empty." *Essai sur les études en Russie*, in *Œuvres*, III, 444.

p. 122 *Primitivism of modern artists.* Here I am much indebted to Robert Goldwater, *Primitivism in Modern Art* (rev. edn., 1967).

p. 124 *Klee on children, madmen, and savages:* "I want to be as though new-born, knowing absolutely nothing about Europe, ignoring poets and fashions, to be almost primitive." Again: "The pictures my little Felix paints are better than mine, which all too often have trickled through the brain." And: "Children, madmen, and savages" have insight into an "in-between world," and pictures of the mentally ill often show admirable "depth and power of expression." Goldwater, *Primitivism*, 199–200.

p. 125 *Kandinsky's discovery of abstract art.* Kandinsky gives an account of this dramatic moment in his little autobiographical sketch, *Rückblicke*, of 1913, conveniently available in a French version of 1946, *Regard sur le passé*.

p. 126 *Klee as craftsman.* "Will and discipline are everything.

Discipline as regards the work as a whole, will as regards its parts. If my works sometimes produce a primitive impression, this 'primitiveness' is explained by my discipline, which consists in reducing everything to a few steps. It is no more than economy; that is, the ultimate professional awareness, which is to say, the opposite of real primitiveness." This from a diary of 1909. Goldwater, *Primitivism*, 201. As "Voltaire" notes, this testimony is extraordinarily valuable, since it is a confession to discipline by a celebrated primitivist. I also like the testimony of Paul Hindemith: "Many composers look at the apparently unprompted appearance of their own work with amazement. They are in a permanent state of artistic narcissism, compared with which the harmless self-admiration of the original Narcissus is but child's play. They will tell you about their creations as they would about natural phenomena or heavenly revelations. You have the impression, not that they themselves did their composing, but that 'it' composed within them almost in spite of their own existence. It is admirable how people can throughout a lifetime maintain this naïve self-confidence." *A Composer's World* (edn. 1961), 67.

V. ON EXISTENTIALISM

p. 134 *Voltaire's preoccupation with Pascal.* In his first polemical work of prose, the *Lettres philosophiques* (1734), Voltaire staged a serious debate with Pascal about their respective views of man. (See Lettre XXV.) This was only the beginning of a lifelong "debate." See J.-R. Carré, *Réflexions sur l'anti-Pascal de Voltaire* (1935).

p. 136 *Voltaire's "Le Monde comme il va."* Written in 1746, this is one of his most representative, if not most distinguished, fables; it deserves to be read by anyone who wants to understand the complex philosophy of the Enlightenment.

p. 139 *David Hume's brave death.* Boswell's reminiscences of this awful encounter were first printed in the *Private Papers of James Boswell*, eds. Geoffrey Scott and Fred-

erick A. Pottle, XII (1931), 227–232. It is reprinted in *Hume's Dialogues Concerning Natural Religion* (ed. Norman Kemp Smith, 2nd edn., 1947), 76–79. See also *E., I*, 356–357.

p. 142 *Latter-day philosophes as Marxists, etc.* The game of finding descendants may be more profitable than that of finding ancestors, but is quite as difficult. Marx, with his critical passion for getting behind the appearances of the economic system to its realities, and with his fierce reformist urge, derives quite directly from the Enlightenment, though the philosophes would have had their fun with his philosophy of history. The logical positivists are plainly in the Enlightenment tradition as well; their debt to Hume's empiricism is great and freely acknowledged, their interest in clarifying language and their intimate relation to the philosophy of science are both significantly foreshadowed in the writings of the more technical of Enlightenment philosophers, notably Condillac. *"The art of reasoning,"* Condillac wrote, *"reduces itself to a well-constructed language." Traité des systèmes,* in *Œuvres philosophiques*, 3 vols. (ed. Georges Le Roy, 1947–1951), I, 131. Again, Condillac urged philosophers quite explicitly to follow the lead of the scientists: "Today," he wrote—the year was 1749—"a few physical scientists, above all the chemists, are concentrating on collecting phenomena, for they have recognized that one must possess the effects of nature, and discover their mutual dependence, before one poses principles that explain them. The example of their predecessors has been a good lesson to them; they at least wish to avoid the errors that the mania for systems has brought in its train. If only all the other philosophers would imitate them!" *Ibid.*, 127.

p. 142 *"Les Philosophes were not philosophers."* This celebrated, much copied, judgment is in Whitehead's *Science and the Modern World*, 86. Obviously, the philosophes themselves thought they *were* philosophers; the very qualities that moved Whitehead to dismiss them—their refusal to think systematically or "deeply," and their engagement

in the battles of the day—moved them to make that claim. See *E.*, *I*, 127–132.

p.143 *Philosophes as triumphant eclectics.* See *E.*, *I*, ch. III, section 2.

p.143 *Humanitarianism from ressentiment.* Both Nietzsche and, in this century, Max Scheler uncovered the hatred that underlies so much benevolence. Nietzsche, of course, was inclined to find the moral rebellion of slaves in Jews and Christians, rather than in the philosophes, much of whose work he strongly admired. And in any event, the philosophes did not pour an indiscriminate benevolence over all of mankind. Voltaire, in fact, put one side of the proposition plainly: "I know how to hate because I know how to love." To Thieriot, December 10, 1738, *Correspondence*, II, 315. The obverse—that they knew how to love because they knew how to hate—is equally true.

p.145 *Carl Becker as critic of the philosophes.* I have borrowed this summary paraphrase of Carl Becker's critical views from R. R. Palmer's review of my *E.*, *I*, in the *Journal of Modern History*, XXXIX, 2 (June 1967), 165.

p.145 *"If men cannot live on bread alone, still less can they do so on disinfectants."* Whitehead, *Science and the Modern World*, 87.

p.146 *The Enlightenment's program of reform.* See *E.*, *II*, ch. VIII.

A note on the word "philosophe." As in my earlier books, so here I have tried to domesticate this French word by keeping it in Roman type. It is, as I have Voltaire say in the text, a French word for an international type, and to assimilate it into English, as we have assimilated so many other French words, would make the international character of the Enlightenment clearer than it has been until now.

ACKNOWLEDGMENTS

I first delivered earlier, and much shorter, versions of these dialogues to the European History Section of the American Historical Association at Toronto, in December 1967, and in the following year at Vassar College. The response of both audiences much encouraged me to enlarge and to publish them. I want to thank John A. Garraty, Richard Hofstadter, and Arthur M. Wilson for their comments on these versions. Sophie Glazer graciously came to my rescue by rapidly and accurately typing the final draft. That draft was closely, critically, and constructively read by Charles M. Gray, David I. Segal, and J. W. Smit, to whom I am deeply in debt. My wife Ruth heard and read every conceivable version of this book, and was, as always, of immense help to me; in addition, she may cheerfully take the blame for originating the whole idea in the first place.

PETER GAY

Woodbridge, Connecticut,
January, 1970

70 71 72 73 12 11 10 9 8 7 6 5 4 3 2 1

Revised January, 1970

hARPER ⚡ ᴛoRChbooKS

† The New American Nation Series, edited by Henry Steele Commager and Richard B. Morris.
‡ American Perspectives series, edited by Bernard Wishy and William E. Leuchtenburg.
a History of Europe series, edited by J. H. Plumb.
§ The Library of Religion and Culture, edited by Benjamin Nelson.
‖ Researches in the Social, Cultural, and Behavioral Sciences, edited by Benjamin Nelson.
Σ Harper Modern Science Series, edited by James A. Newman.
° Not for sale in Canada.
+ Documentary History of the United States series, edited by Richard B. Morris.
Documentary History of Western Civilization series, edited by Eugene C. Black and Leonard W. Levy.
ʌ The Economic History of the United States series, edited by Henry David et al.
¶ European Perspectives series, edited by Eugene C. Black.
** Contemporary Essays series, edited by Leonard W. Levy.
* The Stratum Series, edited by John Hale.

BROADUS MITCHELL: Depression Decade: *From New Era through New Deal, 1929-1941* △ TB/1439
GEORGE E. MOWRY: The Era of Theodore Roosevelt and the Birth of Modern America: 1900-1912. † *Illus.* TB/3022
WILLIAM PRESTON, JR.: Aliens and Dissenters: *Federal Suppression of Radicals, 1903-1933* TB/1287
WALTER RAUSCHENBUSCH: Christianity and the Social Crisis. ‡ *Edited by Robert D. Cross* TB/3059
GEORGE SOULE: Prosperity Decade: *From War to Depression, 1917-1929* △ TB/1349
GEORGE B. TINDALL, Ed.: A Populist Reader: *Selections from the Works of American Populist Leaders* TB/3069
TWELVE SOUTHERNERS: I'll Take My Stand: *The South and the Agrarian Tradition. Intro. by Louis D. Rubin, Jr.; Biographical Essays by Virginia Rock* TB/1072

Art, Art History, Aesthetics

CREIGHTON GILBERT, Ed.: Renaissance Art ** *Illus.* TB/1465
EMILE MALE: The Gothic Image: *Religious Art in France of the Thirteenth Century.* § *190 illus.* TB/344
MILLARD MEISS: Painting in Florence and Siena After the Black Death: *The Arts, Religion and Society in the Mid-Fourteenth Century. 169 illus.* TB/1148
ERWIN PANOFSKY: Renaissance and Renascences in Western Art. *Illus.* TB/1447
ERWIN PANOFSKY: Studies in Iconology: *Humanistic Themes in the Art of the Renaissance. 180 illus.* TB/1077
OTTO VON SIMSON: The Gothic Cathedral: *Origins of Gothic Architecture and the Medieval Concept of Order. 58 illus.* TB/2018
HEINRICH ZIMMER: Myths and Symbols in Indian Art and Civilization. *70 illus.* TB/2005

Asian Studies

WOLFGANG FRANKE: China and the West: *The Cultural Encounter, 13th to 20th Centuries. Trans. by R. A. Wilson* TB/1326
L. CARRINGTON GOODRICH: A Short History of the Chinese People. *Illus.* TB/3015
DAN N. JACOBS, Ed.: The New Communist Manifesto and Related Documents. TB/1078
DAN N. JACOBS & HANS H. BAERWALD, Eds.: Chinese Communism: *Selected Documents* TB/3031
BENJAMIN I. SCHWARTZ: Chinese Communism and the Rise of Mao TB/1308
BENJAMIN I. SCHWARTZ: In Search of Wealth and Power: *Yen Fu and the West* TB/1422

Economics & Economic History

C. E. BLACK: The Dynamics of Modernization: *A Study in Comparative History* TB/1321
STUART BRUCHEY: The Roots of American Economic Growth, 1607-1861: *An Essay in Social Causation. New Introduction by the Author.* TB/1350
GILBERT BURCK & EDITORS OF *Fortune:* The Computer Age: *And its Potential for Management* TB/1179
SHEPARD B. CLOUGH, THOMAS MOODIE & CAROL MOODIE, Eds.: Economic History of Europe: *Twentieth Century* # HR/1388
THOMAS C. COCHRAN: The American Business System: *A Historical Perspective, 1900-1955* TB/1080

ROBERT A. DAHL & CHARLES E. LINDBLOM: Politics, Economics, and Welfare: *Planning and Politico-Economic Systems Resolved into Basic Social Processes* TB/3037
PETER F. DRUCKER: The New Society: *The Anatomy of Industrial Order* TB/1082
HAROLD U. FAULKNER: The Decline of Laissez Faire, 1897-1917 △ TB/1397
PAUL W. GATES: The Farmer's Age: *Agriculture, 1815-1860* △ TB/1398
WILLIAM GREENLEAF, Ed.: American Economic Development Since 1860 + HR/1353
ROBERT L. HEILBRONER: The Future as History: *The Historic Currents of Our Time and the Direction in Which They Are Taking America* TB/1386
ROBERT L. HEILBRONER: The Great Ascent: *The Struggle for Economic Development in Our Time* TB/3030
DAVID S. LANDES: Bankers and Pashas: *International Finance and Economic Imperialism in Egypt. New Preface by the Author* TB/1412
ROBERT LATOUCHE: The Birth of Western Economy: *Economic Aspects of the Dark Ages* TB/1290
W. ARTHUR LEWIS: The Principles of Economic Planning. *New Introduction by the Author°* TB/1436
WILLIAM MILLER, Ed.: Men in Business: *Essays on the Historical Role of the Entrepreneur* TB/1081
GUNNAR MYRDAL: An International Economy. *New Introduction by the Author* TB/1445
HERBERT A. SIMON: The Shape of Automation: *For Men and Management* TB/1245
RICHARD S. WECKSTEIN, Ed.: Expansion of World Trade and the Growth of National Economies ** TB/1373

Historiography and History of Ideas

J. BRONOWSKI & BRUCE MAZLISH: The Western Intellectual Tradition: *From Leonardo to Hegel* TB/3001
WILHELM DILTHEY: Pattern and Meaning in History: *Thoughts on History and Society.° Edited with an Intro. by H. P. Rickman* TB/1075
J. H. HEXTER: More's Utopia: *The Biography of an Idea. Epilogue by the Author* TB/1195
H. STUART HUGHES: History as Art and as Science: *Twin Vistas on the Past* TB/1207
ARTHUR O. LOVEJOY: The Great Chain of Being: *A Study of the History of an Idea* TB/1009
RICHARD H. POPKIN: The History of Scepticism from Erasmus to Descartes. *Revised Edition* TB/1391
MASSIMO SALVADORI, Ed.: Modern Socialism # HR/1374
BRUNO SNELL: The Discovery of the Mind: *The Greek Origins of European Thought* TB/1018
W. WARREN WAGER, ed.: European Intellectual History Since Darwin and Marx TB/1297

History: General

HANS KOHN: The Age of Nationalism: *The First Era of Global History* TB/1380
BERNARD LEWIS: The Arabs in History TB/1029
BERNARD LEWIS: The Middle East and the West ° TB/1274

History: Ancient

A. ANDREWS: The Greek Tyrants TB/1103

ERNST LUDWIG EHRLICH: A Concise History of Israel: *From the Earliest Times to the Destruction of the Temple in A.D. 70* ° TB/128

THEODOR H. GASTER: Thespis: *Ritual Myth and Drama in the Ancient Near East* TB/1281

MICHAEL GRANT: Ancient History ° TB/1190

A. H. M. JONES, Ed.: A History of Rome through the Fifth Century # *Vol. I: The Republic* HR/1364
Vol. II The Empire: HR/1460

NAPHTALI LEWIS & MEYER REINHOLD, Eds.: Roman Civilization *Vol. I: The Republic* TB/1231
Vol. II: The Empire TB/1232

History: Medieval

MARSHALL W. BALDWIN, Ed.: Christianity Through the 13th Century # HR/1468

MARC BLOCH: Land and Work in Medieval Europe. *Translated by J. E. Anderson* TB/1452

HELEN CAM: England Before Elizabeth TB/1026

NORMAN COHN: The Pursuit of the Millennium: *Revolutionary Messianism in Medieval and Reformation Europe* TB/1037

G. G. COULTON: Medieval Village, Manor, and Monastery HR/1022

HEINRICH FICHTENAU: The Carolingian Empire: *The Age of Charlemagne. Translated with an Introduction by Peter Munz* TB/1142

GALBERT OF BRUGES: The Murder of Charles the Good: *A Contemporary Record of Revolutionary Change in 12th Century Flanders. Translated with an Introduction by James Bruce Ross* TB/1311

F. L. GANSHOF: Feudalism TB/1058

F. L. GANSHOF: The Middle Ages: *A History of International Relations. Translated by Rémy Hall* TB/1411

DENYS HAY: The Medieval Centuries ° TB/1192

DAVID HERLIHY, Ed.: Medieval Culture and Society # HR/1340

J. M. HUSSEY: The Byzantine World TB/1057

ROBERT LATOUCHE: The Birth of Western Economy: *Economic Aspects of the Dark Ages* ° TB/1290

HENRY CHARLES LEA: The Inquisition of the Middle Ages. || *Introduction by Walter Ullmann* TB/1456

FERDINARD LOT: The End of the Ancient World and the Beginnings of the Middle Ages. *Introduction by Glanville Downey* TB/1044

H. R. LOYN: The Norman Conquest TB/1457

ACHILLE LUCHAIRE: Social France at the time of Philip Augustus. *Intro. by John W. Baldwin* TB/1314

GUIBERT DE NOGENT: Self and Society in Medieval France: *The Memoirs of Guibert de Nogent*. || *Edited by John F. Benton* TB/1471

MARSILIUS OF PADUA: The Defender of Peace. The Defensor Pacis. *Translated with an Introduction by Alan Gewirth* TB/1310

CHARLES PETET-DUTAILLIS: The Feudal Monarchy in France and England: *From the Tenth to the Thirteenth Century* ° TB/1165

STEVEN RUNCIMAN: A History of the Crusades Vol. I: *The First Crusade and the Foundation of the Kingdom of Jerusalem. Illus.* TB/1143
Vol. II: *The Kingdom of Jerusalem and the Frankish East 1100-1187. Illus.* TB/1243
Vol. III: *The Kingdom of Acre and the Later Crusades. Illus.* TB/1298

J. M. WALLACE-HADRILL: The Barbarian West: *The Early Middle Ages, A.D. 400-1000* TB/1061

History: Renaissance & Reformation

JACOB BURCKHARDT: The Civilization of the Renaissance in Italy. *Introduction by Benjamin Nelson and Charles Trinkaus. Illus.* Vol. I TB/40; Vol. II TB/41

JOHN CALVIN & JACOPO SADOLETO: A Reformation Debate. *Edited by John C. Olin* TB/1239

FEDERICO CHABOD: Machiavelli and the Renaissance TB/1193

J. H. ELLIOTT: Europe Divided, 1559-1598 *a* ° TB/1414

G. R. ELTON: Reformation Europe, 1517-1559 ° *a* TB/1270

DESIDERIUS ERASMUS: Christian Humanism and the Reformation: *Selected Writings. Edited and Translated by John C. Olin* TB/1166

DESIDERIUS ERASMUS: Erasmus and His Age: *Selected Letters. Edited with an Introduction by Hans J. Hillerbrand. Translated by Marcus A. Haworth* TB/1461

WALLACE K. FERGUSON et al.: Facets of the Renaissance TB/1098

WALLACE K. FERGUSON et al.: The Renaissance: *Six Essays. Illus.* TB/1084

FRANCESCO GUICCIARDINI: History of Florence. *Translated with an Introduction and Notes by Mario Domandi* TB/1470

WERNER L. GUNDERSHEIMER, Ed.: French Humanism, 1470-1600. * *Illus.* TB/1473

MARIE BOAS HALL, Ed.: Nature and Nature's Laws: *Documents of the Scientific Revolution #* HR/1420

HANS J. HILLERBRAND, Ed., The Protestant Reformation # TB/1342

JOHAN HUIZINGA: Erasmus and the Age of Reformation. *Illus.* TB/19

JOEL HURSTFIELD: The Elizabethan Nation TB/1312

JOEL HURSTFIELD, Ed.: The Reformation Crisis TB/1267

PAUL OSKAR KRISTELLER: Renaissance Thought: *The Classic, Scholastic, and Humanist Strains* TB/1048

PAUL OSKAR KRISTELLER: Renaissance Thought II: *Papers on Humanism and the Arts* TB/1163

PAUL O. KRISTELLER & PHILIP P. WIENER, Eds.: Renaissance Essays TB/1392

DAVID LITTLE: Religion, Order and Law: *A Study in Pre-Revolutionary England. § Preface by R. Bellah* TB/1418

NICCOLO MACHIAVELLI: History of Florence and of the Affairs of Italy: *From the Earliest Times to the Death of Lorenzo the Magnificent. Introduction by Felix Gilbert* TB/1027

ALFRED VON MARTIN: Sociology of the Renaissance. ° *Introduction by W. K. Ferguson* TB/1099

GARRETT MATTINGLY et al.: Renaissance Profiles. *Edited by J. H. Plumb* TB/1162

J. H. PARRY: The Establishment of the European Hegemony: 1415-1715: *Trade and Exploration in the Age of the Renaissance* TB/1045

J. H. PARRY, Ed.: The European Reconnaissance: *Selected Documents #* HR/1345

J. H. PLUMB: The Italian Renaissance: *A Concise Survey of Its History and Culture* TB/1161

A. F. POLLARD: Henry VIII. *Introduction by A. G. Dickens.* ° TB/1249

RICHARD H. POPKIN: The History of Scepticism from Erasmus to Descartes TB/1391

PAOLO ROSSI: Philosophy, Technology, and the Arts, in the Early Modern Era 1400-1700. || *Edited by Benjamin Nelson. Translated by Salvator Attanasio* TB/1458

4

R. H. TAWNEY: The Agrarian Problem in the Sixteenth Century. *Intro. by Lawrence Stone*
TB/1315
H. R. TREVOR-ROPER: The European Witch-craze of the Sixteenth and Seventeenth Centuries and Other Essays ° TB/1416
VESPASIANO: Rennaissance Princes, Popes, and XVth Century: *The Vespasiano Memoirs. Introduction by Myron P. Gilmore. Illus.*
TB/1111

History: Modern European

RENE ALBRECHT-CARRIE, Ed.: The Concert of Europe # HR/1341
MAX BELOFF: The Age of Absolutism, 1660-1815
TB/1062
OTTO VON BISMARCK: Reflections and Reminiscences. *Ed. with Intro. by Theodore S. Hamerow* ¶ TB/1357
EUGENE C. BLACK, Ed.: British Politics in the Nineteenth Century # HR/1427
D. W. BROGAN: The Development of Modern France ° Vol. I: *From the Fall of the Empire to the Dreyfus Affair* TB/1184
Vol. II: *The Shadow of War, World War I, Between the Two Wars* TB/1185
ALAN BULLOCK: Hitler, A Study in Tyranny. ° *Revised Edition. Iuus.* TB/1123
GORDON A. CRAIG: From Bismarck to Adenauer: *Aspects of German Statecraft. Revised Edition* TB/1171
LESTER G. CROCKER, Ed.: The Age of Enlightenment # HR/1423
JACQUES DROZ: Europe between Revolutions, 1815-1848. ° *a Trans. by Robert Baldick*
TB/1346
JOHANN GOTTLIEB FICHTE: Addresses to the German Nation. *Ed. with Intro. by George A. Kelly* ¶ TB/1366
ROBERT & ELBORG FORSTER, Eds.: European Society in the Eighteenth Century # HR/1404
C. C. GILLISPIE: Genesis and Geology: *The Decades before Darwin* § TB/51
ALBERT GOODWIN: The French Revolution
TB/1064
JOHN B. HALSTED, Ed.: Romanticism # HR/1387
STANLEY HOFFMANN et al.: In Search of France: *The Economy, Society and Political System In the Twentieth Century* TB/1219
H. STUART HUGHES: The Obstructed Path: *French Social Thought in the Years of Desperation* TB/1451
JOHAN HUIZINGA: Dutch Civilisation in the 17th Century and Other Essays TB/1453
WALTER LAQUEUR & GEORGE L. MOSSE, Eds.: Education and Social Structure in the 20th Century. ° *Volume 6 of the* Journal of Contemporary History TB/1339
WALTER LAQUEUR & GEORGE L. MOSSE, Eds.: International Fascism, 1920-1945. ° *Volume 1 of the* Journal of Contemporary History
TB/1276
WALTER LAQUEUR & GEORGE L. MOSSE, Eds.: Literature and Politics in the 20th Century. ° *Volume 5 of the* Journal of Contemporary History. TB/1328
WALTER LAQUEUR & GEORGE L. MOSSE, Eds.: The New History: *Trends in Historical Research and Writing Since World War II.* ° *Volume 4 of the* Journal of Contemporary History
TB/1327
WALTER LAQUEUR & GEORGE L. MOSSE, Eds.: 1914: *The Coming of the First World War.* ° *Volume3 of the* Journal of Contemporary History TB/1306
JOHN MCMANNERS: European History, 1789-1914: *Men, Machines and Freedom* TB/1419

PAUL MANTOUX: The Industrial Revolution in the Eighteenth Century: *An Outline of the Beginnings of the Modern Factory System in England* TB/1079
KINGSLEY MARTIN: French Liberal Thought in the Eighteenth Century: *A Study of Political Ideas from Bayle to Condorcet* TB/1114
NAPOLEON III: Napoleonic Ideas: *Des Idées Napoléoniennes, par le Prince Napoléon-Louis Bonaparte. Ed. by Brison D. Gooch* ¶
TB/1336
FRANZ NEUMANN: Behemoth: *The Structure and Practice of National Socialism, 1933-1944*
TB/1289
DAVID OGG: Europe of the Ancien Régime, 1715-1783 ° *a* TB/1271
GEORGE RUDE: Revolutionary Europe, 1783-1815 ° *a* TB/1272
MASSIMO SALVADORI, Ed.: Modern Socialism #
TB/1374
DENIS MACK SMITH, Ed.: The Making of Italy, 1796-1870 # HR/1356
ALBERT SOREL: Europe Under the Old Regime, *Translated by Francis H. Herrick* TB/1121
ROLAND N. STROMBERG, Ed.: Realism, Naturalism, and Symbolism: *Modes of Thought and Expression in Europe, 1848-1914* # HR/1355
A. J. P. TAYLOR: From Napoleon to Lenin: *Historical Essays* ° TB/1268
A. J. P. TAYLOR: The Habsburg Monarchy, 1809-1918: *A History of the Austrian Empire and Austria-Hungary* ° TB/1187
J. M. THOMPSON: European History, 1494-1789
TB/1431
DAVID THOMSON, Ed.: France: Empire and Republic, 1850-1940 # HR/1387
H. R. TREVOR-ROPER: Historical Essays TB/1269
W. WARREN WAGAR, Ed.: Science, Faith, and MAN: *European Thought Since 1914* #
HR/1362
MACK WALKER, Ed.: Metternich's Europe, 1813-1848 # HR/1361
ELIZABETH WISKEMANN: Europe of the Dictators, 1919-1945 ° *a* TB/1273
JOHN B. WOLF: France: 1814-1919: *The Rise of a Liberal-Democratic Society* TB/3019

Literature & Literary Criticism

JACQUES BARZUN: The House of Intellect
TB/1051
W. J. BATE: From Classic to Romantic: *Premises of Taste in Eighteenth Century England*
TB/1036
VAN WYCK BROOKS: Van Wyck Brooks: *The Early Years: A Selection from his Works, 1908-1921 Ed. with Intro. by Claire Sprague*
TB/3082
RICHMOND LATTIMORE, Translator: The Odyssey of Homer TB/1389
ROBERT PREYER, Ed.: Victorian Literature **
TB/1302
BASIL WILEY: Nineteenth Century Studies: *Coleridge to Matthew Arnold* ° TB/1261
RAYMOND WILLIAMS: Culture and Society, 1780-1950 ° TB/1252

Philosophy

HENRI BERGSON: Time and Free Will: *An Essay on the Immediate Data of Consciousness* °
TB/1021
LUDWIG BINSWANGER: Being-in-the-World: *Selected Papers. Trans. with Intro. by Jacob Needleman* TB/1365
H. J. BLACKHAM: Six Existentialist Thinkers: *Kierkegaard, Nietzsche, Jaspers, Marcel, Heidegger, Sartre* ° TB/1002

6

MARTIN BUBER: Eclipse of God: *Studies in the Relation Between Religion and Philosophy* TB/12
MARTIN BUBER: Hasidism and Modern Man. *Edited and Translated by Maurice Friedman* TB/839
MARTIN BUBER: The Knowledge of Man. *Edited with an Introduction by Maurice Friedman. Translated by Maurice Friedman and Ronald Gregor Smith* TB/135
MARTIN BUBER: Moses. *The Revelation and the Covenant* TB/837
MARTIN BUBER: The Origin and Meaning of Hasidism. *Edited and Translated by Maurice Friedman* TB/835
MARTIN BUBER: The Prophetic Faith TB/73
MARTIN BUBER: Two Types of Faith: *Interpenetration of Judaism and Christianity* ° TB/75
MALCOLM L. DIAMOND: Martin Buber: *Jewish Existentialist* TB/840
M. S. ENSLIN: Christian Beginnings TB/5
M. S. ENSLIN: The Literature of the Christian Movement TB/6
HENRI FRANKFORT: Ancient Egyptian Religion: *An Interpretation* TB/77
MAURICE S. FRIEDMAN: Martin Buber: *The Life of Dialogue* TB/64
ABRAHAM HESCHEL: The Earth Is the Lord's & The Sabbath. *Two Essays* TB/828
ABRAHAM HESCHEL: God in Search of Man: *A Philosophy of Judaism* TB/807
ABRAHAM HESCHEL: Man Is not Alone: *A Philosophy of Religion* TB/838
ABRAHAM HESCHEL: The Prophets: *An Introduction* TB/1421
T. J. MEEK: Hebrew Origins TB/69
JAMES MUILENBURG: The Way of Israel: *Biblical Faith and Ethics* TB/133
H. H. ROWLEY: The Growth of the Old Testament TB/107
D. WINTON THOMAS, Ed.: Documents from Old Testament Times TB/85

Religion: Early Christianity Through Reformation

ANSELM OF CANTERBURY: Truth, Freedom, and Evil: *Three Philosophical Dialogues. Edited and Translated by Jasper Hopkins and Herbert Richardson* TB/317
MARSHALL W. BALDWIN, Ed.: Christianity through the 13th Century # HR/1468
ADOLF DEISSMAN: Paul: *A Study in Social and Religious History* TB/15
EDGAR J. GOODSPEED: A Life of Jesus TB/1
ROBERT M. GRANT: Gnosticism and Early Christianity TB/136
WILLIAM HALLER: The Rise of Puritanism TB/22
ARTHUR DARBY NOCK: St. Paul ° TR/104
GORDON RUPP: Luther's Progress to the Diet of Worms ° TB/120

Religion: The Protestant Tradition

KARL BARTH: Church Dogmatics: *A Selection. Intro. by H. Gollwitzer. Ed. by G. W. Bromiley* TB/95
KARL BARTH: Dogmatics in Outline TB/56
KARL BARTH: The Word of God and the Word of Man TB/13
WHITNEY R. CROSS: The Burned-Over District: *The Social and Intellectual History of Enthusiastic Religion in Western New York, 1800-1850* TB/1242
WILLIAM R. HUTCHISON, Ed.: American Protestant Thought: *The Liberal Era* ‡ TB/1385

SOREN KIERKEGAARD: The Journals of Kierkegaard. ° *Edited with an Intro. by Alexander Dru* TB/52
SOREN KIERKEGAARD: The Point of View for My Work as an Author: *A Report to History.* § *Preface by Benjamin Nelson* TB/88
SOREN KIERKEGAARD: The Present Age. § *Translated and edited by Alexander Dru. Introduction by Walter Kaufmann* TB/94
SOREN KIERKEGAARD: Purity of Heart. *Trans. by Douglas Steere* TB/4
SOREN KIERKEGAARD: Repetition: *An Essay in Experimental Psychology* § TB/117
SOREN KIERKEGAARD: Works of Love: *Some Christian Reflections in the Form of Discourses* TB/122
WOLFHART PANNENBERG, et al.: History and Hermeneutic. *Volume 4 of* Journal for Theology and the Church, *edited by Robert W. Funk and Gerhard Ebeling* TB/254
F. SCHLEIERMACHER: The Christian Faith. *Introduction by Richard R. Niebuhr.*
Vol. I TB/108; Vol. II TB/109
F. SCHLEIERMACHER: On Religion: *Speeches to Its Cultured Despisers. Intro. by Rudolf Otto* TB/36
PAUL TILLICH: Dynamics of Faith TB/42
PAUL TILLICH: Morality and Beyond TB/142

Religion: The Roman & Eastern Christian Traditions

A. ROBERT CAPONIGRI, Ed.: Modern Catholic Thinkers II: *The Church and the Political Order* TB/307
G. P. FEDOTOV: The Russian Religious Mind: *Kievan Christianity, the tenth to the thirteenth Centuries* TB/370
GABRIEL MARCEL: Being and Having: *An Existential Diary. Introduction by James Collins* TB/310
GABRIEL MARCEL: Homo Viator: *Introduction to a Metaphysic of Hope* TB/397

Religion: Oriental Religions

TOR ANDRAE: Mohammed: *The Man and His Faith* § TB/62
EDWARD CONZE: Buddhism: *Its Essence and Development.* ° *Foreword by Arthur Waley* TB/58
EDWARD CONZE: Buddhist Meditation TB/1442
EDWARD CONZE et al, Editors: Buddhist Texts through the Ages TB/113
ANANDA COOMARASWAMY: Buddha and the Gospel of Buddhism TB/119
H. G. CREEL: Confucius and the Chinese Way TB/63
FRANKLIN EDGERTON, Trans. & Ed.: The Bhagavad Gita TB/115
SWAMI NIKHILANANDA, Trans. & Ed.: The Upanishads TB/114

Religion: Philosophy, Culture, and Society

NICOLAS BERDYAEV: The Destiny of Man TB/61
RUDOLF BULTMANN: History and Eschatology: *The Presence of Eternity* ° TB/91
RUDOLF BULTMANN AND FIVE CRITICS: Kerygma and Myth: *A Theological Debate* TB/80
RUDOLF BULTMANN and KARL KUNDSIN: Form search. *Trans. by F. C. Grant* TB/96
LUDWIG FEUERBACH: The Essence of Christianity. § *Introduction by Karl Barth. Foreword by H. Richard Niebuhr* TB/11
KYLE HASELDEN: The Racial Problem in Christian Perspective TB/116

7

MARTIN HEIDEGGER: Discourse on Thinking. *Translated with a Preface by John M. Anderson and E. Hans Freund. Introduction by John M. Anderson* TB/1459

IMMANUEL KANT: Religion Within the Limits of Reason Alone. § *Introduction by Theodore M. Greene and John Silber* TB/FG

H. RICHARD NIEBUHR: Christ and Culture TB/3

H. RICHARD NIEBUHR: The Kingdom of God in America TB/49

JOHN H. RANDALL, JR.: The Meaning of Religion for Man. *Revised with New Intro. by the Author* TB/1379

Science and Mathematics

W. E. LE GROS CLARK: The Antecedents of Man: *An Introduction to the Evolution of the Primates.* ° *Illus.* TB/559

ROBERT E. COKER: Streams, Lakes, Ponds. *Illus.* TB/586

ROBERT E. COKER: This Great and Wide Sea: *An Introduction to Oceanography and Marine Biology. Illus.* TB/551

F. K. HARE: The Restless Atmosphere TB/560

WILLARD VAN ORMAN QUINE: Mathematical Logic TB/558

Science: Philosophy

J. M. BOCHENSKI: The Methods of Contemporary Thought. *Tr. by Peter Caws* TB/1377

J. BRONOWSKI: Science and Human Values. *Revised and Enlarged. Illus.* TB/505

WERNER HEISENBERG: Physics and Philosophy: *The Revolution in Modern Science. Introduction by F. S. C. Northrop* TB/549

KARL R. POPPER: Conjectures and Refutations: *The Growth of Scientific Knowledge* TB/1376

KARL R. POPPER: The Logic of Scientific Discovery TB/576

Sociology and Anthropology

REINHARD BENDIX: Work and Authority in Industry: *Ideologies of Management in the Course of Industrialization* TB/3035

BERNARD BERELSON, Ed., The Behavioral Sciences Today TB/1127

KENNETH B. CLARK: Dark Ghetto: *Dilemmas of Social Power. Foreword by Gunnar Myrdal* TB/1317

KENNETH CLARK & JEANNETTE HOPKINS: A Relevant War Against Poverty: *A Study of Community Action Programs and Observable Social Change* TB/1480

LEWIS COSER, Ed.: Political Sociology TB/1293

ROSE L. COSER, Ed.: Life Cycle and Achievement in America ** TB/1434

ALLISON DAVIS & JOHN DOLLARD: Children of Bondage: *The Personality Development of Negro Youth in the Urban South* || TB/3049

ST. CLAIR DRAKE & HORACE R. CAYTON: Black Metropolis: *A Study of Negro Life in a Northern City. Introduction by Everett C. Hughes. Tables, maps, charts, and graphs* Vol. I TB/1086; Vol. II TB/1087

PETER F. DRUCKER: The New Society: *The Anatomy of Industrial Order* TB/1082

LEON FESTINGER, HENRY W. RIECKEN, STANLEY SCHACHTER: When Prophecy Fails: *A Social and Psychological Study of a Modern Group that Predicted the Destruction of the World* || TB/1132

CHARLES Y. GLOCK & RODNEY STARK: Christian Beliefs and Anti-Semitism. *Introduction by the Authors* TB/1454

L. S. B. LEAKEY: Adam's Ancestors: *The Evolution of Man and His Culture. Illus.* TB/1019

KURT LEWIN: Field Theory in Social Science: *Selected Theoretical Papers.* || *Edited by Dorwin Cartwright* TB/1135

RITCHIE P. LOWRY: Who's Running This Town? *Community Leadership and Social Change* TB/1383

R. M. MACIVER: Social Causation TB/1153

GARY T. MARX: Protest and Prejudice: *A Study of Belief in the Black Community* TB/1435

ROBERT K. MERTON, LEONARD BROOM, LEONARD S. COTTRELL, JR., Editors: Sociology Today: *Problems and Prospects* || Vol. I TB/1173; Vol. II TB/1174

GILBERT OSOFSKY, Ed.: The Burden of Race: *A Documentary History of Negro-White Relations in America* TB/1405

GILBERT OSOFSKY: Harlem: The Making of a Ghetto: *Negro New York 1890-1930* TB/1381

TALCOTT PARSONS & EDWARD A. SHILS, Editors: Toward a General Theory of Action: *Theoretical Foundations for the Social Sciences* TB/1083

PHILIP RIEFF: The Triumph of the Therapeutic: *Uses of Faith After Freud* TB/1360

JOHN H. ROHRER & MUNRO S. EDMONSON, Eds.: The Eighth Generation Grows Up: *Cultures and Personalities of New Orleans Negroes* || TB/3050

ARNOLD ROSE: The Negro in America: *The Condensed Version of Gunnar Myrdal's An American Dilemma. Second Edition* TB/3048

GEORGE ROSEN: Madness in Society: *Chapters in the Historical Sociology of Mental Illness.* || *Preface by Benjamin Nelson* TB/1337

PHILIP SELZNICK: TVA and the Grass Roots: *A Study in the Sociology of Formal Organization* TB/1230

PITIRIM A. SOROKIN: Contemporary Sociological Theories: *Through the First Quarter of the Twentieth Century* TB/3046

MAURICE R. STEIN: The Eclipse of Community: *An Interpretation of American Studies* TB/1128

FERDINAND TONNIES: Community and Society: *Gemeinschaft und Gesellschaft. Translated and Edited by Charles P. Loomis* TB/1116

SAMUEL E. WALLACE: Skid Row as a Way of Life TB/1367

W. LLOYD WARNER and Associates: Democracy in Jonesville: *A Study in Quality and Inequality* || TB/1129

W. LLOYD WARNER: Social Class in America: *The Evaluation of Status* TB/1013

FLORIAN ZNANIECKI: The Social Role of the Man of Knowledge. *Introduction by Lewis A. Coser* TB/1372